D0200220

ART
ANSWERS

Watercolor
PAINTING

EXPERT ANSWERS
TO THE QUESTIONS
EVERY ARTIST ASKS

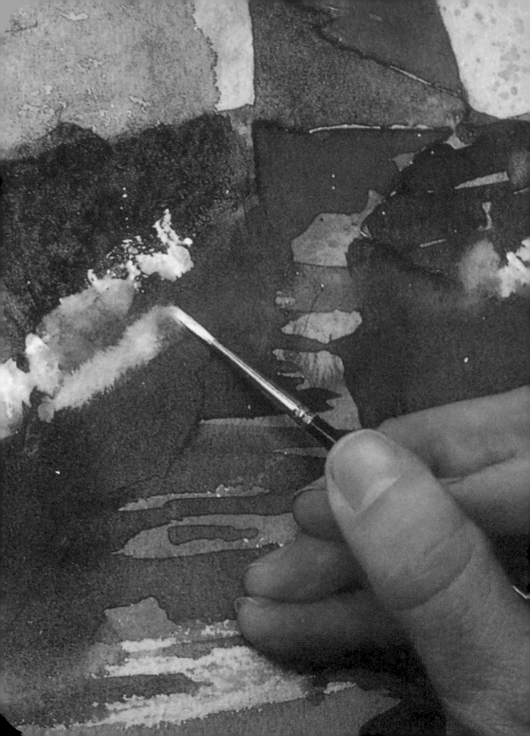

ART ANSWERS

Watercolor
PAINTING

EXPERT ANSWERS
TO THE QUESTIONS
EVERY ARTIST ASKS

GEORGE JAMES

A Quantum Book

Copyright © 2012 Quantum Publishing

First edition for North America and the Philippines published in 2012 by
Barron's Educational Series, Inc.

All inquiries should be addressed to:
Barron's Educational Series, Inc.
250 Wireless Boulevard
Hauppauge, New York 11788
www.barronseduc.com

ISBN: 978-1-4380-0022-0

Library of Congress Control Number: 2011926020

This book is published and produced by
Quantum Books
6 Blundell Street
London N7 9BH

QUMAAW2

Publisher: Sarah Bloxham
Managing Editor: Julie Brooke
Consultant Editor: George James
Editor: Carolyn Madden
Project Editor: Samantha Warrington
Assistant Editor: Jo Morley
Design: Jeremy Tilston
Production: Rohana Yusof

Printed in China by Midas Printing International Ltd.

9 8 7 6 5 4 3 2 1

The material in this book has previously appeared in: *Introduction to Painting with Watercolor,*
The Complete Watercolor Artist, The Watercolor Artist's Handbook, Painting in Watercolor,
Techniques Sourcebook Watercolor Painting, An Introduction to Painting in Watercolor,
Watercolor Painting.

Contents

Introduction

BY GEORGE JAMES

What is a watercolor painting but paint, brushes, paper, and water? And yet it has appealed to humanity through the millennia and across continents. The ways of this medium have been practiced in the Orient since 300 BC and in Europe since 1400 AD. There is a Chinese saying which describes the painter who believed in "the song of the brush."

In Europe, the great German artist Albrecht Dürer's sixteenth-century watercolor landscapes earned him the title, "the father of watercolor." England gave recognition to watercolor painting through the greatest watercolorist of all, J.M.W. Turner (1775–1851). Turner was rumored to have produced over 19,400 watercolors in his lifetime.

Armed with this historic tradition, along with the availability of libraries, press, publications, and the Internet, paintings by these watercolor masters can be seen, studied, revisited, and sometimes even imitated — all for learning's sake.

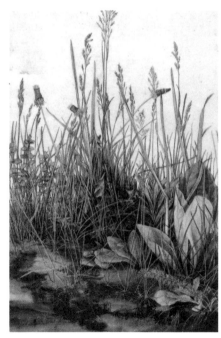

Above: The Great Piece of Turf, *Albrecht Dürer. The artist found his medium in watercolor, and, while we cannot be sure of his precise technique, he probably began by using transparent washes, then built up intricate details with body color.*

Above: Flo and Me at the Opera, *George James. This painting was executed in watercolor on Yupo synthetic paper. It achieved great success at the 2011 American Watercolor Society exhibition, winning the Di Di Deglin award.*

Perhaps the most obvious difference between then and now is the availability of materials for painting. Modern chemistry gives today's artist paint that is rich in color, synthetic brushes that rival the best of animal hair brushes, and synthetic papers such as Yupo paper. Creative watercolor painting, then, becomes a reflection of the dynamic times in which we live.

To quote Aristotle, *"Art not only imitates nature, but also completes its deficiencies."* To solve deficiencies, on the spot, resources such as this book can answer questions quickly and efficiently. However, there is no replacement for practice, at least seven watercolors a week. No excuses! To quote my favorite university professor:

"Your first thousand watercolors should stay close to representation. Your second thousand can explore abstraction and design."

Perhaps after a few thousand watercolors, you will find that you have fallen in love with paint and paper.

Ars longa, vita brevis.
Art is long, life is short.

Good luck!

George James

George James

1

EQUIPMENT AND WORKSPACE

What basic equipment do I need for indoor painting?

Watercolor painting requires little specialist equipment. Here is a basic list: more detail is given later in the book.

1 Tubes

Watercolor paint can come in tubes, ready for dilution.

2 Pans

Watercolor is also sold in cubes of paint called pans: whole or half-sized. Keep them clean to avoid color contamination.

3 Paintbox

A paintbox holds pans which can be replaced and has its own palette.

4 White gouache

White gouache is a highly concentrated opaque white. Mixed with watercolors, it makes them opaque, a medium which is called "body color." It is also used for highlights.

5 Pencils

Pencils range from 6H (very hard, light line) to 9B (very soft, dark line). Watercolor artists normally use HB to 4B.

6 Erasers

Soft erasers leave a residue which must be brushed off the paper. Hard erasers rub pigment off with friction.

7 & 8 Containers

Plastic containers with a lid are ideal for outdoor work. Indoors, glass jars allow the artist to check on water purity.

9 & 10 Palettes

A wide range of palettes are available, including ceramic (9) and plastic (10), in many shapes and sizes.

11 Brushes

Brushes are usually sable or synthetic. Sable offer the best quality and return to the original shape readily.

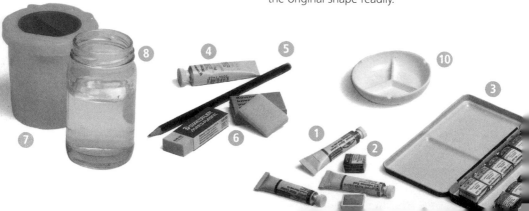

Are there basic equipment requirements for outdoor painting?

When working on location, the emphasis is on compactness and portability, depending on your mode of transport and location.

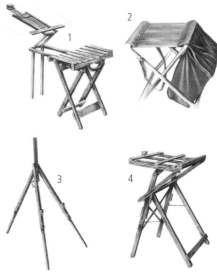

Portable easels

One of the best types of easel for working outside is the combined sketching seat and easel (1). Another useful piece of outdoor equipment is the combined satchel and stool (2). The sketching easel can be fitted with spikes to anchor it into the ground and is adjustable in height (3). The combination easel can be used both as an easel and a drawing table (4). It is compact, making it easy to store.

Other portable materials

A watercolor box containing dry pans is light and provides a palette. Heavy duty paper in blocks or single watercolor boards are less bulky than paper on board. One brush or sponge for laying washes and another medium brush with a good point will serve your needs. Transport them in a shop-bought tube to protect the brush tips. A wide-bottomed jam jar with a tightly fitting lid makes a suitable water container.

OUTDOOR MATERIALS:

Portable easel
Watercolor box
Heavy duty paper in blocks or single sheets
Watercolor boards
Brushes (in tube)
Sponge
A water container

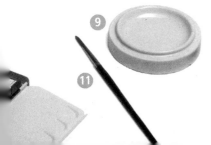

What special equipment is needed before I start?

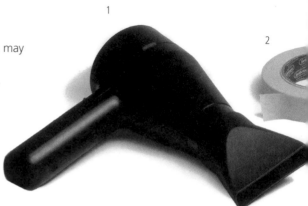

Listed here are the special items you may need when beginning to paint with watercolor, in addition to the paints, paper, brushes, and palettes. They can be used for various basic watercolor techniques. Later in the book, experimental techniques may require other items, which are identified with each project.

1 Hair dryer

A hair dryer is used for drying intermediate washes and to speed up the process of stretching paper. Be careful when using electrical items near water.

2 Masking tape

Use masking tape to mask the edge of the picture or as a straight-edged mask during painting. It has low adhesion and will not tear the paper when peeled off.

3 Gummed paper

When stretching paper, use 2 in. (5 cm) wide gummed paper to withstand the stresses of paper stretching.

4 Small natural sponges

Natural sponges can be used for lifting off wet paint, or to produce fine irregular patterns in paint.

5 Cotton swabs

Cheap and readily available, cotton swabs are well suited for lifting off small areas of wet paint for highlights, as they absorb more rapidly than a brush.

6 Masking fluid

Masking fluid is a liquid rubber solution, which is painted on to protect specific areas from paint. It has a short shelf life: throw it away when it discolors.

7 Synthetic sponges

Synthetic sponges are ideal for wetting down the paper. Small pieces can be torn off for texturing effects.

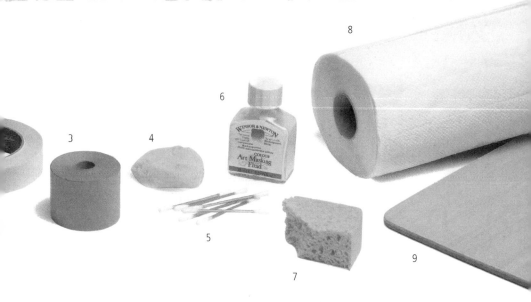

8 Tissue

Absorbent tissue has several uses, including cleaning, lifting off, and removing stray splashes. Highlights and cloud effects can be produced by lifting out paint with crumpled tissue.

9 Board

A board is used to hold the paper flat and secure when painting. It should be lightweight and resistant to warping. Thin-cross plywood is best suited to the purpose.

How do I organize my materials?

Place a table near to your work table for your materials: paints, brushes, water, sponges, knives, and erasers. The location of each item should be considered with care; carrying the loaded brush across a longer distance than necessary risks spilling paint.

Two water receptacles are needed, one to mix with the paint, the other for rinsing out the brushes and for emergencies such as blotting off random spillages or mistakes. Jars and pots with wide bases ensure that no slight knock will upset them.

What is watercolor paint?

Watercolor is paint consisting of pigment bound in gum Arabic, requiring only water as a medium. Transparency is the characteristic of watercolor, and the traditional technique is to lay in light tones first and build gradually to dark areas.

Types of watercolor

Ready-made watercolor paint is sold in various forms, the commonest being tubes, pans, and half-pans. These all contain glycerine and are known as semi-moist colors, unlike the traditional dry cakes, which require considerable rubbing with water before the color is released.

Gouache paints, or designer's colors as they are also known, are normally sold in tubes. These paints, and the cheaper versions of them, poster colors and powder paints, have chalk added to the pigment to thicken it, and are thus opaque, unlike true watercolor. Watercolors themselves can be mixed with Chinese white to make them opaque or semi-opaque, so that they become a softer and more subtle form of gouache.

Choosing paints

When buying watercolors, price more accurately reflects the quality than in any other medium. Success in watercolor painting depends so much on applying layers of rich color. It is a mistake to buy anything but the best-quality paints, known as "artist's quality."

In this expensive, highest-quality range, there is no essential difference — except in terms of portability and convenience — between "solid" and tube colors. The quality names to consider are: Winsor and Newton, Rowney, Reeves, and Grumbacher.

ARTIST'S TIP

Some colors are considerably less permanent than others, which may not be a consideration for quick sketches, but is clearly important for any painting that is intended to be hung or exhibited. All manufacturers grade permanence. It is wise to rule out any colors classified as "fugitive."

Is there a good starter palette of colors?

Few watercolor artists, even the most expert, would claim to use more than ten to 12 colors, from which the whole range could be mixed. An adequate modern palette is illustrated here.

Professional artists may argue about the "best" basic palette, but most advise that a beginner should stick to a restricted palette, which not only forces the artist to consider the basics of color mixing but imposes a pleasing harmony and consistency on the finished work.

Selecting the most suitable kind of paint requires careful thought. It is a good idea to experiment with the

difference between types. Pans and half-pans (cubes of semi-moist paint) are especially convenient for working outdoors on a small scale. For an ambitious large scale work being developed in the studio, tubed watercolor is convenient for squeezing out in larger quantities.

Remember that the character of the painting will be affected by the paint used: dry cakes will need more water to release a strong stain of pigment than tubes, and the semi-moist pans stand somewhere between these two.

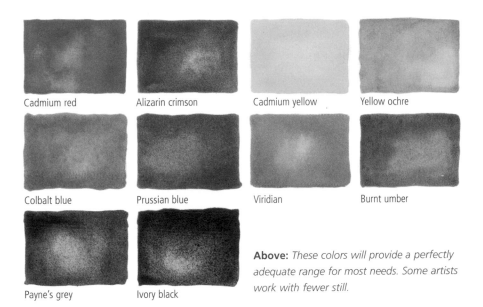

Cadmium red Alizarin crimson Cadmium yellow Yellow ochre

Colbalt blue Prussian blue Viridian Burnt umber

Payne's grey Ivory black

Above: *These colors will provide a perfectly adequate range for most needs. Some artists work with fewer still.*

What papers are made for watercolor?

In watercolor painting, the traditional support — the surface on which painting is done — is white or pale paper, which reflects back through the transparent paint to give the translucent quality characteristic of watercolors.

Paper types

The three main types of machine-made paper are hot-pressed (HP), cold-pressed (CP), which is also known as "not" for "not hot-pressed," and rough.

Hot-pressed paper is smooth and, although suitable for drawing or pen-and-wash, is not a good choice for building up layers of washes because it becomes clogged quickly. Cold-pressed paper, which is slightly textured, is the most popular, and is suitable for both broad washes and fine detail. Rough paper is much more heavily textured, giving a speckled effect to the paint, which can be effective but is difficult to exploit successfully.

Hand-made papers are made from pure linen rag and specially treated with size to provide the best possible surface for watercolor work. Such papers are "sized" on one side only and therefore have a right and wrong side: hold the paper up to the light so that the watermark becomes visible. Many of the better machine-made papers also have a watermark and, therefore, a right and wrong side.

Brands

Among the best watercolor papers are those by Saunders, Fabriano, Arches, Bockingford, Strathmore, and R.W.S. (Royal Watercolor Society), including handmade papers.

Yupo is a non-absorbent synthetic paper. It works well with all water-media paint, and is available from large art supply companies.

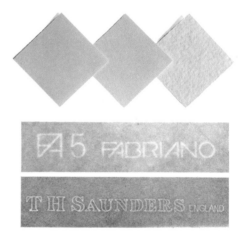

Above: *Three main paper surfaces are available to buy: hot-pressed has a fairly smooth surface (left), not (or cold-pressed) which comes as semi-rough (center) or rough (right).*

What are the weights and sizes of watercolor paper?

Grades and sizes

The grading of paper is by weight of the ream (usually 500 sheets). This varies from 40-44 lb (16.5-17 kg) for a lightweight paper to 400 lb (165 kg) for the heaviest paper. The weight is important: the heavier the paper, the more ready it is to accept water, and the lighter papers are in need of stretching before they will present a surface on which to paint. Heavier grades of paper, upward of 140 lb (65 kg) can be worked on without stretching.

Paper sizes

Cheaper papers such as cartridge are classified by the international A sizes; for better quality, handmade and mould-made papers, traditional sizes are still used.

Antiquarian	31 x 53 in. (79 x 135 cm)
Double Elephant	27 x 40 in. (69 x 102 cm)
Elephant	23 x 28 in. (58 x 71 cm)
Imperial	30 x 22 in. (76 x 56 cm)
Half Imperial	15 x 22 in. (38 x 56 cm)
Royal	19½ x 24 in. (49 x 61 cm)

ARTIST'S TIP

All watercolor papers should be stored in as dry a place as possible. Damp may activate chemical impurities, producing spots which will not take color.

Which paper would be recommended for beginners?

A good paper for beginners in the medium is Saunders machine-made 90 lb (40 kg), 30 x 22 in. (76 x 56 cm), with a cold-pressed surface. It is tough, stretches well if needed to take heavy washes, and stands up to drawing and erasing.

How is paper stretched?

Lightweight papers, ranging from 70 lb (32 kg) to 140 lb (65 kg), which tend to buckle when washes are applied, should be stretched before use. As the paper must be dry, it needs to be stretched at least two hours before you start work.

1 Check the watermark to ensure that the paper is the right side up.

2 Trim the paper to size for the drawing board, leaving a 0.5 in. (2 cm) margin of board for the gummed paper to adhere to.

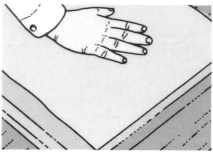

3 Soak the paper thoroughly by laying it in a tray or sink of clean water.

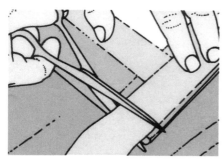

4 Measure out lengths of gummed paper to match each side of the drawing board.

5 Shake off the surplus water and lay the paper, painting surface up, on a drawing board. Stick damped, gummed paper along one side.

6 Stick the remaining edges down with strips of gummed paper.

7 Put a drawing pin in each corner. As the watercolor paper dries, it will pull itself smooth and tight.

Is special equipment needed to stretch paper?

None apart from a drawing board, gummed paper, and drawing pins. Special stretching frames or striators can be bought, on to which heavier weights of paper can be stretched and held taut, with the edges crimped between an inner and outer framework. These are for experts, and provide a pleasant "give" to the paper similar to that of an oil canvas. But even experts have been known to tear their wash-weakened paper; and some artists believe that such stretching adversely affects the surface texture of the paper.

For field work, some artists use a light panel of wood or Masonite, trimmed smaller than the cut paper. Two or three sheets of dampened paper are laid over the thin board, folded down and under, and held in place with a number of spring clips. The toughness of the dried stretched paper holds it in place when the clips are removed; and a completed sheet can be taken off without disturbing the lower sheets.

Right: *Use gummed paper to secure the watercolor paper.*

Which brushes should I use?

The art of brush manufacture is exacting: skilled labor and rare materials mean that the best brushes can seem prohibitively expensive; however, they will last longer and will serve you better than cheaper ones. Many watercolor boxes include a brush, but these are usually poor quality. A typical watercolor brush has three main parts: the handle or shaft, the hairs, and the ferrule or metal sleeve that attaches the hairs to the handle. In a good-quality brush, the ferrule secures the hair firmly. There should be no individual hairs coming loose.

Choosing your brushes

Only trial and error will show what size and shape of brush is most suited to your style. However, it is usual to keep a few larger brushes for laying on washes and a few smaller ones for putting in detail. Soft sable brushes are best for most techniques, and these are produced in different series by several manufacturers. The Winsor and Newton Series 7 is the highest quality red sable brush available. Handles are always shorter than those used for oil painting because watercolor brushes need to be manipulated easily.

Painters often use a set of brushes which become shaped to their own hand. Peter de Wint (1784–1849) painted with only two brushes, one thick and stubby and the other finer, which he squeezed to form a splayed end. After years of use, these brushes took on a particular character and would have been useless to anyone else.

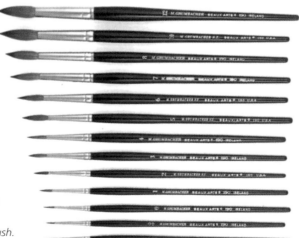

Right: *This series of brushes shows all the different sizes available in one brand of brush.*

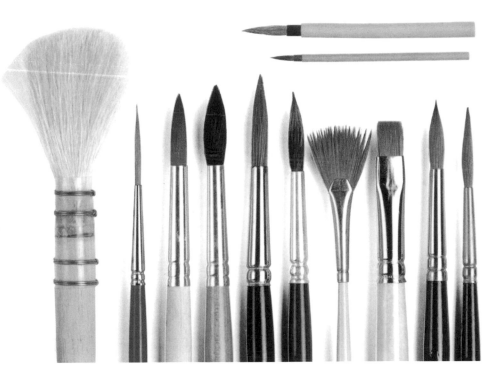

Above: *Japanese bamboo brushes (top) are versatile and convenient both for covering large areas and for detailed work with the brush tip. A range of brushes suitable for watercolor painting is shown here* (from left to right): *blender, fine synthetic round hair, broad synthetic round hair, mixed fibers round, ox hair round, squirrel hair round, sable fan bright, chisel-ended, sable round, fine sable round.*

What do the numbers on the brushes mean?

Brushes are graded according to size, ranging from 0, or even 00 and 000, to as large a size as 14. There are other shapes available, the most common being the chisel or square-ended. On a wet surface, a flat brush comes into its own, carrying a large amount of pigment while the paper supplies the water.

What types of palette are available?

Watercolor palettes are made in plastic, metal, or ceramic, in a variety of sizes, and some have a thumbhole so that they can be held in the non-painting hand.

Any plate or dish can be used for mixing watercolor, but specially made palettes, with recesses, help you to work cleanly and prevent colors from running together. If you buy paints in paintbox form, you will already have a palette in the lid; if not, you will need one with compartments for mixing paint. There are many different kinds of palette available, but they all have recessed wells to hold color and divisions to separate one color from another.

Plastic palettes are a good all-purpose choice: inexpensive and light, they are ideal for outdoor work, especially those with the thumbhole. Individual palettes, made of ceramic or plastic, are useful for indoor work. You can keep each color separate and can stack the palettes after use.

If you buy pans or half-pans of watercolor and a suitable paintbox, you can mix colors in the box. Although tube colors can be mixed in a paintbox, many people prefer a palette.

Right: *The circular palette* (top left), *also available in plastic, is favored by many artists. The thumbhole variety of plastic palettes* (center left) *are especially useful when working outside.*

What other equipment could be useful?

Watercolor is a versatile medium, and can be worked with a wide variety of "tools" to create stunning effects (see the chapter on *Special Techniques).* Various other pieces of equipment, though not strictly essential, can be useful and inexpensive aids for your watercolor work.

Rags are useful for applying large areas of irregular washes. The uneven way in which a rag distributes paint creates an unpredictable and beautiful wash, which is ideal for representing skies.

Toothbrushes are ideal for spattering paint to create textured effects, to suggest sand or pebbles on a beach.

A scalpel, or a razor blade, is often used to scrape away small areas of paint to create highlights, which can be highly effective where fine highlights, such as ripples of light on water, are required. If you are working with gouache or watercolor, a palette knife can be used for pushing paint around, creating textures, or scraping paint back off the paper surface.

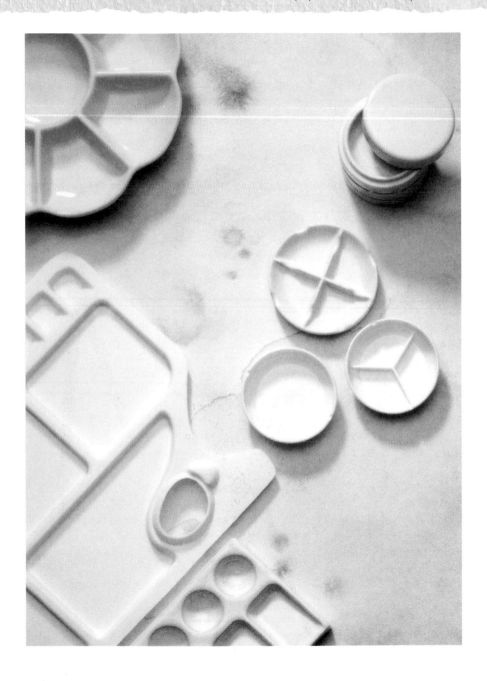

Do I need an easel for indoor work?

Watercolors, unlike oils, are best done at close quarters, with the support held nearly horizontal, so that an easel is not really necessary for indoor work.

However, an easel can be helpful. It allows you to tilt the work at different angles (many artists prefer to do preliminary drawings with the board held vertically) and to move it around to the best light, which is more difficult with a table. The most important . aspects to consider — apart, of course, from price — are stability and the facility for holding the work firmly in a horizontal position.

For indoor work, the combination easel, which can be used both as a drawing table and a studio easel, is very convenient (see *Are there basic equipment requirements for outdoor painting?*). The combination easel is adjustable to any angle, from vertical to horizontal. Good easels are not cheap, however, so that it is wise to do without one until you are sure of your requirements; many professional watercolor artists work at an ordinary table with their board supported by a book or brick.

Below: *There are two main types of sketching easel: wooden ones and metal ones. They both weigh about the same, and the height and angle can be adjusted.*

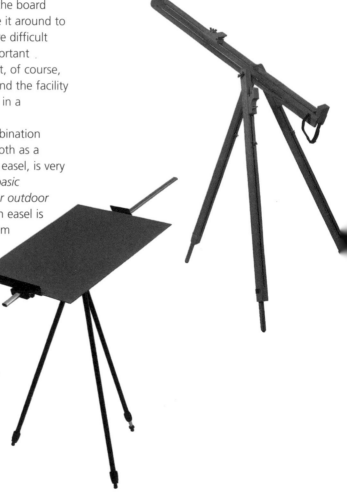

Is special clothing needed?

No specialist clothing is necessary when painting in watercolor. Whether to wear protective clothing is a matter of individual need and comfort.

When painting indoors, you may wish to protect your clothes by wearing an apron, white coat, or artist's smock. Even an old, over-sized shirt is suitable to keep paint and masking fluid away from clothing. Ensure that the sleeves roll up or the garment is short-sleeved, to avoid smudging paint.

Painting outdoors may require further thought, in order to protect yourself from the sun and rain. A hat, fingerless gloves, a large sporting umbrella, and a ground sheet are all useful. Consider also whether you want a stool or deck chair for comfort, bearing in mind that you have to carry it.

What type of board is required?

You will need a drawing board, or possibly two boards of different sizes, to support the paper and for stretching it where necessary. A piece of plywood or blockboard is perfectly adequate, provided the surface is smooth and the wood soft enough to take drawing pins. For outdoor work, a piece of hardboard can be used, with the paper clipped to it, though the paper must be heavy enough not to require stretching.

Left: *A smooth wooden board that is soft enough to take drawing pins is ideal.*

Are there special pencils for watercolor artists?

A useful tool for watercolor artists is the water-soluble pencil. This pencil is available in all colors, as well as tonal wash values. These pencils are very useful for working in the small, detailed areas of the painting.

Is a drawing table useful?

Most artists have some type of table that allows them to place their work comfortably and securely. Professional drawing tables are modeled after smaller versions of drafting tables in that they allow for adjusting the height as well as the angle the artist prefers for his work. This table is another form of the watercolor easel for the studio.

Do I need a light table?

Having a light table is helpful for tracing images, as well as sorting and preparing photographic slides for exhibition. Some artists use a light box when preparing their slides for their own personal records.

What is a taboret?

A taboret is a small boxlike table. It is used as a platform for water, brushes, palettes, and other tools. Some more elaborate taborets have drawer space designed into the box for storage. They may also come with casters for easy maneuvering of the box to the workstation. Taborets can be built into the easel, but these rather elaborate and expensive systems are usually reserved for situations where there is very limited workspace available.

What is an art projector?

An art projector is useful when tracing photos or sketches. It projects the image on to the support so that it can be traced or used for visualization purposes.

Many realist painters use this tool when composing complex images, as it gives accurate, detailed results. Tracing the image also resolves issues with drawing.

How do I store my watercolor paintings?

The simplest method for storing watercolor work is in flat drawers away from the light and damp. Professional drawers come in large formats of up to 30 x 40 in. (76 x 101 cm). They are available in metal or wood. The metal version is usually less expensive.

Do I need a portfolio?

When the time comes to show your work, you will need a portfolio. This will be where you will accumulate and save your best efforts. Professional portfolios can be quite elaborate. They may be made of a variety of materials from durable black vinyl to expensive leather. They can have handles and carrying straps as well as acetate sleeves to protect the work.

Right: *A portfolio allows your work to be stored and carried safely, as well as providing a neat way to present your work and relevant sketches.*

CHAPTER

2

COLOR AND COMPOSITION

What are the unique properties of watercolor?

Watercolors obey all the same color laws as other media, but there is one important difference: watercolor is transparent. Instead of adding white to make a color paler, you add more water, causing greater fluidity. The color of the paper, usually white but occasionally tinted, plays an intrinsic part, because the colors laid on to it are transparent glazes that allow the paper to show through.

Each color has different physical properties, which you need to understand, as it will affect the way you mix and use it. Some colors are very concentrated, and you only need a small amount; otherwise they will overpower other colors on the palette. These strong colors tend to be the dyes like alizarin crimson and phthalocyanine blue. Others are granular, leaving grainy textures, but are less intense in hue.

Experimenting with colors before you begin painting will help you to develop a better sense of their qualities.

What are the primary colors?

A little knowledge of basic color theory is essential for the aspiring artist, and will help you learn to mix colors successfully. The three primary colors — red, yellow, and blue — are those that cannot be mixed from any other color. These are the foundation stones of color. From these you can mix the three secondary colors — orange, green, and purple — then the three tertiary colors (mixtures of three colors) and so on. In theory, you can mix all colors from the primaries. In practice, this may not be true, as commercially produced paint pigments are unlikely to be sufficiently pure.

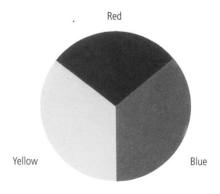

Red

Yellow

Blue

What are warm colors?

Not all primary colors are the same; there are different reds, blues, and yellows. A very helpful distinction to make is the color "temperature." In the overall color spectrum, red and yellow can be described as "warm" colors and at the other end, blue and purple as "cool." The same distinction can be made within each color group, albeit more subtly. Shown in the warm color wheel *(right)* are warm versions of the primary colors, with the secondary colors produced by mixing them.

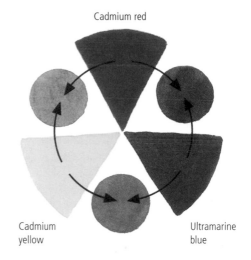

Cadmium red

Cadmium yellow

Ultramarine blue

What are cool colors?

The primary colors on this color wheel *(right)* are the cooler versions.
For example, the yellow has no red in it and veers toward the green. The red has no yellow in it and veers toward the purple, while the blue has no red content and veers toward the green. The secondaries produced when these are mixed are different from their counterparts on the warm wheel.

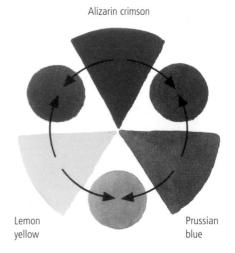

Alizarin crimson

Lemon yellow

Prussian blue

Is there an example of "warm temperature" color in painting?

This painting, Moira Clinch's *La Bougainvillea*, shows how warm pigments can be mixed to great effect. The warm colors of burnt sienna, yellow ochre, and burnt umber form the basis of the painting. The versatility of a single watercolor pigment is demonstrated by the fact that burnt umber was used to depict both the somber nature of the gate and the delicate plasterwork of the wall. The only difference between the two is the amount of water used to apply the paint.

Above: A strong diluted flat underwash of burnt sienna was used as the basis for the brickwork. Individual bricks were then overpainted in diluted mixtures of cadmium deep red, raw sienna, and yellow ochre.

Below: La Bougainvillea, *Moira Cinch.*

Above: *The shadows on the flowers and gate were added by subduing the main colors with indigo and a little black.*

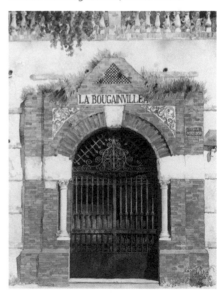

Is there an example of "cool temperature" color in painting?

This painting by John Lidzey, *Fen Cottage*, is taken from a sketchbook, and shows the art of mixing colors very clearly. The artist has used the actual page as a palette on which to mix and drop in the fluid colors. A very limited selection of colors was used to convey this dull winter's day.

The cool colors — ultramarine, indigo, and Payne's grey — and the spiky, linear pencil drawing emphasize the bleak atmosphere, but this is cleverly counterbalanced by thin washes and mixes of alizarin crimson and yellow ochre, giving the painting gentle touches of warmth.

Above: *This skeleton drawing of the tree is given substance by washes of yellow ochre and ultramarine, with a little alizarin crimson for warmth.*

Above: *The basis of the whole painting can be seen in this detail: the artist has used various mixes of ultramarine, indigo, alizarin crimson, and yellow ochre to create the desired cool and warm tones.*

Above: *Dots and blobs of white gouache were used to depict the blossom on the leafless tree.*

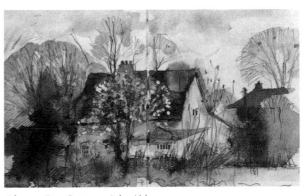

Above: Fen Cottage, *John Lidzey.*

When are colors complementary?

Complementary colors, as opposed to light complementaries (see *What are the additive primaries?*), are those pairs which are at opposite sides of the color sphere, with the same degree of intensity: red and green, blue and orange, or yellow and purple. It can be seen that each of the primary colors — red, blue, and yellow — has as its complementary the color formed by the mixture of the other two.

When two complementary colors are seen together, the intensity sets off the same degree of reaction in the rods on the back of the retina: at the same time their intensity and brightness are not reduced or modified, as is the case with other colors. Rather they are enhanced, and can set up the sort of dazzle which we often associate with the close proximity of bright colors. This was a characteristic of Op Art.

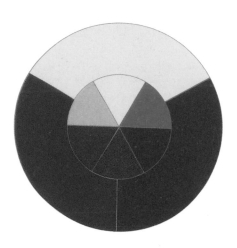

Above: *The primary pigments are red, yellow, and blue. Three secondary colors can be produced by mixing the primaries as follows: red and yellow make orange, yellow and blue produce green, and red and blue create a brownish purple* (above right).

The complementary colors are those at the opposite sides of the color wheel, green being the complementary of red, purple of yellow, and orange of blue. Each pair of complementary colors contains no common primary color.

What are the additive primaries?

There are actually two sets of primary colors: those produced by pigments (these pigment primaries are red, yellow, and blue) and those produced by light (these light primaries are red, green, and blue–violet). Primary light colors are different from primary pigment colors, and the effect of mixing light is very different. A mixture of two pigments will result in a darker color. The three primary pigments, when mixed together, result in black, but the mixture of light will result in a lighter color.

This mixing of light is called an additive process. Although initially it might seem confusing (this being the opposite to what we experience when mixing paints), it does make good sense. Absence of light produces, naturally, black, and the more light used in mixing, the lighter the color produced.

Therefore a mixture of red and green will produce yellow, red and blue–violet produces magenta, blue–violet and green will produce blue–green or cyan. A mixture of all these light primaries, red, green and blue–violet, will result in white being produced.

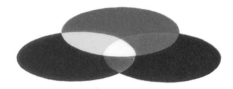

Above: *Additive primaries: these are the light primaries, red, green, and blue–violet. Just as the absence of light produces darkness, so mixing light will result in a lighter color, and mixing three light primaries produces white.*

What are subtractive primaries?

A mixture of two pigments will result in a darker color; a mixture of three primary pigments together results in black. These are subtractive primaries.

Right: *Subtractive primaries: these are the pigment primaries, and mixing them has a different result from that of mixing light primaries. Combining two of them produces a darker color, while all three together make black.*

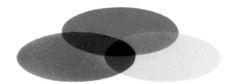

What are tone and hue?

Two ways in which color can be differentiated are in terms of tone and hue. Hue describes the color itself, while tone is the darkness or lightness of the color.

A whole range of tones can be present in a single-colored object, and a good exercise would be to paint a single-colored object lit only from one side. This would produce a whole range of tones of one hue in the object, ranging from highlights to deep shadows.

Tone is often difficult to assess, and many artists find themselves squinting. This has the advantage of reducing detail and giving a view of the object or landscape as a whole, allowing the artist to assess the tones more easily.

Consider a landscape, where most of the painting will be made up of a variety of greens. How can you make these greens more interesting as colors?

Are they warm, cool, brilliant, dull, acid? What evidence of other colors do they show? A red flag on a golf course will bring out the contrast of the greens more sharply. Experimentation in mixing up a variety of greens will show how wide your choice of hues can be; by stretching your blues and yellows to the furthest edge of your color spectrum, and by making your greens as warm and as cool as possible by adding more blue or red hues, you will see how exciting a range is obtainable.

A shadow or a changing surface is not necessarily merely a darker tone of the same color. The tone of the shadow may tend toward warm or cool grey; in some cases, it may be purple or, for example with a green object, it may be its complementary, red. These areas need to be examined carefully, and a selective eye is needed to record colors seen and not colors as they are thought to be seen.

A good exercise for practicing this vision is to paint a still life entirely composed of white objects. You will find that you use the whole range of your palette — not simply white, black, and grey.

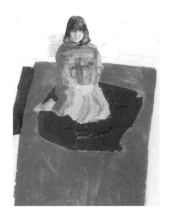

Left: *When complementary pairs are seen together, their intensity is enhanced, which creates a sort of dazzle effect, as seen in this painting.*

Does drying lighten color?

Watercolors look darker when wet than when dry, so you may find that a wash is less intense than you thought. You can compensate by laying a secondary wash over the first when it has dried, but it is wise to try out a mixture on a spare piece of paper first.

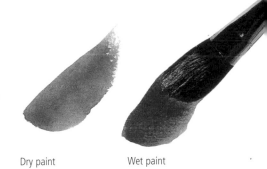

Right: *This example clearly shows the right-hand wet brushstroke is darker than the dry one on the left.*

Dry paint Wet paint

How do I make color paler?

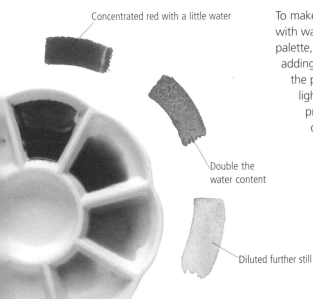

Concentrated red with a little water

Double the water content

Diluted further still

To make a color paler, you simply dilute it with water. This is generally done in the palette, although it can also be done by adding extra water to the wet paint on the paper surface. When mixing a light color in the palette, add water progressively with a wet brush or dropper, then mix it in well. With experience, you will be able to judge at this stage how it will appear, but a large amount of wet paint can look misleadingly dark, so make sure of the dilution by trying swatches on paper.

What is granulation?

Some pigments are dyes that stain the paper, but others have sedimentary qualities, and as they dry, they settle into granular textures. When you begin painting, this may not seem desirable; but once this characteristic is understood, it can be utilized to create interesting effects.

Manganese blue is one of the most granular, followed by cobalt blue, ultramarine blue, and the earth colors. The effect can be enhanced by mixing some of these colors together.

Left: *A vertical strip of manganese blue has been painted over horizontal strips of alizarin crimson, viridian, and cadmium yellow. The granulation of the blue allows the undercolors to show through, highlighting the grainy texture.*

Left: *Manganese blue is mixed with burnt umber, cadmium yellow, and burnt sienna. Interesting textured effects are created because, although the two colors do mix, the manganese blue still separates out.*

Can color be mixed on paper?

When two colors are mixed wet on the paper surface, they blend erratically, with exciting results, rather than the even color produced in a palette. You can brush them together on the paper or allow the water to blend them together.

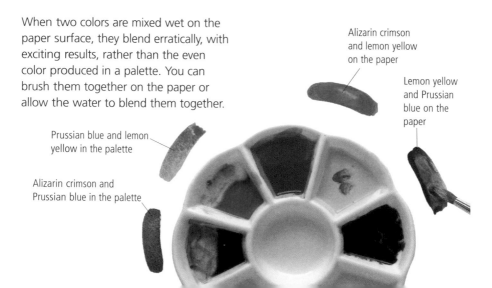

Alizarin crimson and lemon yellow on the paper

Lemon yellow and Prussian blue on the paper

Prussian blue and lemon yellow in the palette

Alizarin crimson and Prussian blue in the palette

Is there an explanation for two-color and three-color mixes?

Two-color mixes

At the outer edges of this chart *(right)* are the 14 colors in a suggested starter palette, seven running down the left-hand side and seven along the top. The squares show the colors mixed together in equal proportions. Further variations can be made by altering the proportions or adding more water.

	Lemon yellow	Cadmium yellow	Yellow ochre	Sap green	Viridian	Burnt sienna	Burnt umber
Cadmium red							
Alizarin crimson							
Ultramarine blue							
Cobalt blue							
Cerulean blue							
Prussian blue							
Payne's grey							

Three-color mixes

When the three primary colors are mixed together, they have the effect of canceling each other out, producing a neutral grey. By using more of one color than another, you can give the neutral a more distinctive bias — for example a warm or cool grey *(right)*, or various shades of brownish grey. It is important to understand how to mix these neutral colors without producing muddy hues, as many subtle nuances of color are found in nature.

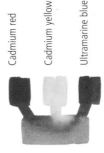

Cadmium red • Cadmium yellow • Ultramarine blue

Above: *The three warm primaries are mixed equally to produce warm grey.*

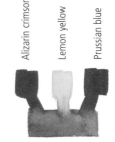

Alizarin crimson • Lemon yellow • Prussian blue

Above: *The three cool primaries are mixed equally to produce cool grey.*

Can a transparent overlay of colors create new colors?

Because watercolor is transparent, you can mix colors on the paper surface by laying one over another dry color. This can create a fresher, more vibrant effect than pre-mixing in the palette. Overpainting colors has to be done carefully in one stroke, to avoid disturbing the undercolor.

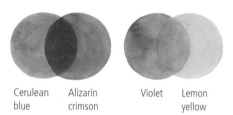

Cerulean blue | Alizarin crimson Violet | Lemon yellow

Alizarin crimson Cadmium orange

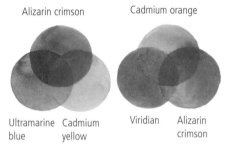

Ultramarine blue | Cadmium yellow Viridian | Alizarin crimson

Above: *These examples show the overlaying of first two colors and then three, where all three circles meet. Subtle color mixes can be achieved, which may have a bias to the more dominant color. The first mixtures, for example, are dominated by the alizarin crimson.*

What are the most transparent colors?

Some colors are more transparent than others. Swatches of colors have been painted over a bar of ultramarine to demonstrate this *(right)*.

Pigments are derived from different sources, either organic or inorganic, and they have different properties which affect their transparency. The sedimentary colors like burnt umber, for example, tend to be slightly opaque, while the staining colors such as alizarin crimson are very transparent.

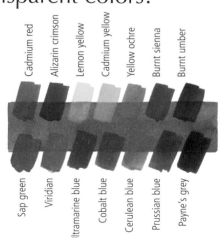

Cadmium red Alizarin crimson Lemon yellow Cadmium yellow Yellow ochre Burnt sienna Burnt umber

Sap green Viridian Ultramarine blue Cobalt blue Cerulean blue Prussian blue Payne's grey

How is mood expressed through color?

Mood, atmosphere, a certain intangible quality conveyed by the way light falls on a subject, combine to create *"the spell that charges the commonplace with beauty,"* to quote from the great British photographer Bill Brandt.

Tonal values play a major role in creating the mood in your pictures. There is a strong connection between the value range in a painting and the mood it conveys; a preponderance of dark values gives a somber or mysterious atmosphere, whereas plenty of light values create a lively, bold, or cheerful impression.

The way light and dark values are arranged and distributed can also have an influence on the emotional impact of a painting. For example, dark values in the lower half of the painting convey a feeling of strength and stability; but if the dark values occupy the upper half of the composition, as in a storm scene, the mood alters radically, becoming somber and threatening.

Understanding the ways in which tonal values can be organized and used as a means of expression help the artist to bring atmosphere to the painting, to create powerful and compelling images.

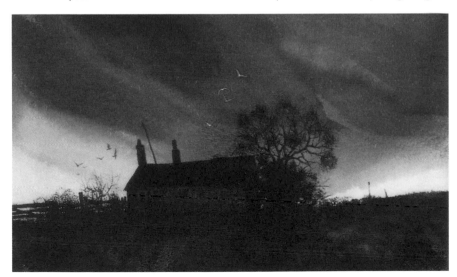

Above: Storm from the Sea, *Stan Perrott. Strong tonal contrasts here add impact, with dark, swirling clouds radiating from the center of the picture in a dramatic way, creating an intense and foreboding atmosphere.*

What is meant by keying your values?

The term "key" refers to the overall lightness or darkness of a particular painting. A dimly lit interior could be termed "low-key" because it would contain mainly dark values. A cornfield in summer would be a "high-key" painting, because it contains mainly light values. The Impressionists created high-key paintings of heady summer days: the Dutch masters contrasted muted darks with soft highlights in low-key portraits.

Look at any successful painting, and you will see that it has a good key — there is a unity, a feeling of strength and solidity that stems from the harmony of values and colors. Values play a vital role in establishing the overall atmosphere or mood of a picture.

How is a value sketch made?

A value sketch uses tonal values to create a balanced and unified composition. In nature, the range of values from the darkest dark to the lightest light is extremely wide — far wider than we could ever hope to attain in a painting.

As artists, we are obliged to select from nature only those elements that seem to capture the essence of the subject, and ignore the inconsequential details; in order to give a painting more force, we have to portray what we see in a crystallized form. How do we begin this process of selection?

The answer is simple: before you begin painting, make a few pencil sketches of the subject in which you concentrate only on the main shapes and value masses. These sketches are useful, firstly, because they provide a way of getting familiar with the subject, so you feel more confident when starting to paint it and, secondly, because you can use them to try out different arrangements of lights and darks until you arrive at the one that seems best. Making preliminary sketches will save you a lot of time and frustration at the painting stage.

How many values should I start with?

Where many amateur artists go wrong is in not understanding the importance of using a limited range of values to express a particular mood and to give greater power and directness to their paintings. When a painting contains too many

different values, it becomes patchy and confused: the emotional message becomes dissipated. It is far better to use a limited range of values initially, no more than five, and exploit them to the full. Add four more when you feel confident.

Above: *By squinting, the artist reduces the scene to just four values. He ties similar values together, making stronger shapes.*

Above: *Now he works over the areas of darkest value to strengthen them.*

How do I make a value scale?

Draw a bar 5 in. (12.5 cm) long and 1 in. (2.5 cm) wide on a sheet of white paper. Divide the bar into 1 in. (2.5 cm) squares. Leaving the first square white, use an HB pencil to lightly fill in the other four squares with hatched lines. Go over the hatched lines again, this time starting with the third square. Now go over squares four and five again, and finally go over square five only.

As long as you exert the same degree of pressure with the pencil each time, this should give you an even gradation in value from white to black.

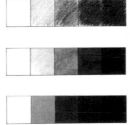

Left: *Use value scales to assess the tones in your work. In this sketch* (far left) *the artist establishes the main value masses, then adds middle values.*

Is there an example of a high-key painting?

In a high-key painting, most of the colors are in the light-to-middle value range, and there are no sharp contrasts of value. This creates a slightly hazy, atmospheric effect that is ideal for expressing qualities such as delicacy, tenderness, softness, fragility, or purity.

To create a high-key painting, use pale, gentle colors mixed with a lot of white and work wet-in-wet so that one color blends softly into another with no abrupt change in value. To keep the colors lively and luminous, don't overmix them on the palette; it's far better to do

as the Impressionists did and use small strokes and dabs of broken color which blend in the viewer's eye while still retaining their individual vibrancy.

The trick is to deliberately emphasize the lightness and brightness of the scene — to paint it lighter and brighter than it actually appears if necessary — in order to make a more forceful statement about your emotional response to the fleeting effects of light. Remember to keep the shadows soft, in keeping with the high-key effect.

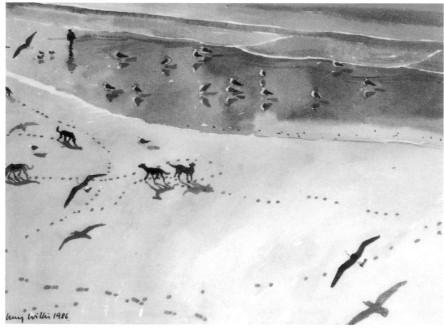

Above: Watching Gulls, *Lucy Willis. The shadows accentuate the bright sunlight.*

What defines a middle-key painting?

When handled skilfully, a painting in mainly middle values creates a subtle and harmonious image. However, a middle-key painting is in danger of emerging flat and lifeless unless it contains some positive contrasts, so introduce a few lights or rich darks to give it more depth

Consider the choice of colors in a middle-key painting. As you are sacrificing the drama of chiaroscuro (light/dark contrast), it is vital that the image is exciting in terms of color. Select colors that are close in value but contrasting in temperature or intensity, for a harmonious, vibrant picture.

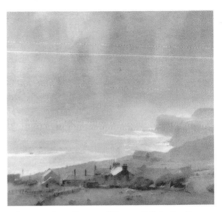

Above: Hazy Sun and Damp Mist, Boulby Down, *Trevor Chamberlain. The artist has worked wet-in-wet, controlling the tones.*

What properties does a low-key painting have?

A low-key painting is one that is predominantly dark in value, and such paintings create a very different mood. In our subconscious minds, darkness is associated with night, which in turn we link with mystery, suspense, and emotions such as sadness, fear, and loneliness. Dark values can also create a feeling of strength and calm.

Choose your subject carefully, and use colors in the mid-to-dark value range, to exploit the psychological effects of darkness and shadow, creating dramatic images. Low-key portraits are effective, creating a sense of introspection.

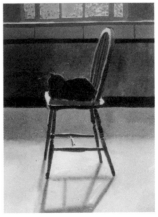

Left: Cat on a Chair, *Lucy Willis. Low-key but not somber.*

How is light related to mood in watercolors?

In any painting, one of the most important elements to consider is light, because light affects both the values and colors of a picture, and both have a significant effect on mood. Claude Monet explained it when he said:

"For me, a landscape does not exist in its own right, since its appearance changes at every moment; but the surrounding atmosphere brings it to life — the air and the light, which vary continually."

How do I use light to create the mood?

Making a series of paintings of the same subject over a period of time is a valuable exercise, because it demonstrates how even small changes in the lighting can alter the balance of values in a picture, and therefore the mood it conveys. The seasons, especially, offer splendid opportunities to explore the magic of light on the landscape.

Viewpoint and composition are important elements in creating mood. The brooding atmosphere of an approaching storm is made more dramatic by placing the horizon line very low to emphasize the sky.

To capture a fleeting mood successfully, it is best to restrict yourself to a limited number of values. Light is elusive and ever-changing, so you have to sacrifice details and concentrate on capturing the essentials. Try making a few simple monochrome sketches in watercolor, using only five values: these will give you enough information about

the mood of the scene to be able to create a full-scale painting in the studio. This method forces you to work from memory when recording the details of form and color. Memory is selective, editing out the superfluous details, leaving you with a clear recollection of the elements that most impressed you at first sight. This process of distillation is vital to the success of a picture, because your aim is to communicate to the viewer the thrill of the first impression, uncluttered by distracting details.

Right: Beach Boats, *Lucy Willis. This painting emanates a bracing, seaside atmosphere. A sprinkling of dark values helps to accentuate the crisp, bright light that fills the scene.*

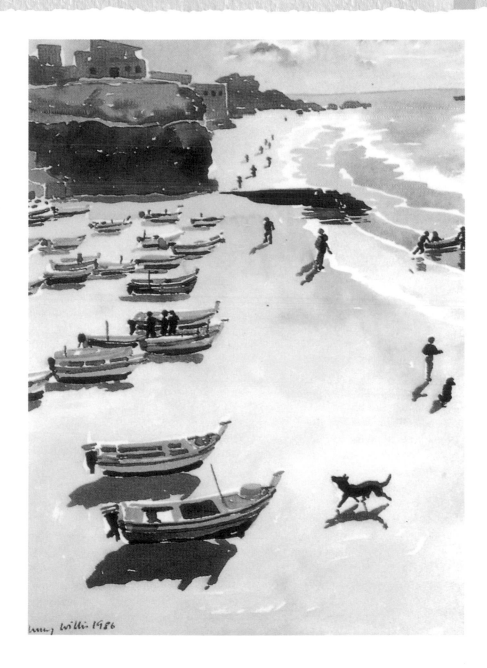

Should composition be considered before starting a painting?

When about to embark on a painting, be certain that you have looked at it from every angle. The rearrangement of a still life, for instance, may make an enormous difference, and small thumbnail sketches will help you to remember any previous arrangements which you may have thought more suitable.

When considering a landscape, the placing of the horizon line is important. Consider the difference between a bird's eye view and that of a worm, and all the variations in between; thumbnail sketches are again very useful in helping you decide.

To a certain extent, arriving at a successful composition is a matter of trial and error, it being necessary to try out a number of different groupings of objects and figures before you arrive at the best solution.

Scale is another important factor, not only in giving clues about perspective and depth but also in determining the compositional impact of your painting. Difference in scale can heighten dramatic interest: a small, single figure conveying loneliness and isolation; a close-up view of a face giving a feeling either of intrusion or intimacy.

Some artists cut a hole in a thick piece of card of the same proportions as their support and use it as a viewfinder, as in a camera. It is possible to view a still life or landscape through this hole, considering a variety of proportions and viewpoints. Generally speaking, it is better not to place your main object of interest right in the center of your picture plane.

Above: *Small thumbnail sketches are a useful aid, whether you are considering a still life, landscape, or group of figures. These examples show sketches of female nudes in various poses and against slightly differing backgrounds; they form the basis on which the artist will decide on the best composition for his finished painting.*

How do I decide the composition size and shape?

Before starting your painting, you must consider how to devise a visually interesting picture and to arrange color, shape, and lines on your support in a way that will best suit your purpose. This is the essence of composition.

Different objects and parts of your picture must be related to each other; if your composition is poor, you will fail to convey the meaning and thought behind your work. Theories have been evolved over the centuries, but the reading and understanding of these theories is not a substitute for practice.

Many paintings are based on the arrangement of geometric shapes such as triangles, circles, and squares. Some have strong linear compositions, both vertically and horizontally; vertical lines give a feeling of stability and peace, while horizontal lines tend to convey dignity. This is necessarily an oversimplified analysis, and it is essential to try to analyze more complicated structures by looking at as many paintings as possible and understanding their intrinsic design.

When you start work, you have to choose paper or canvas of appropriate size and, unless you are making a square painting, decide whether you want to use it in portrait or landscape format. This depends on your choice of subject and the best view of it.

Some artists start painting without deciding on the final dimensions of the painting, letting the shape gradually emerge. Alternatively, an unusual format — such as a long, narrow rectangle — may suggest a particular treatment of the subject.

If you work on paper, you don't have to fill the given rectangle (see *What are the dynamics of a rectangular painting?*). You can trim it or, later on, use a mat to contain the picture area. However, it is easier to begin with a format that will work for the painting you have in mind.

When you select the size of paper for your painting, consider it in terms of the actual scale of your subject. A small landscape can be powerful, but you might prefer the spacious feel of a larger picture. Similarly, a small-scale subject on a larger picture area may mean that you end up painting the objects larger than lifesize. This can look strange because objects naturally relate to a personal sense of scale, and when you paint them over lifesize, you may find that you encounter problems with proportions and the relationships between them.

In composition, what is the Golden Section?

The Golden Section was a rule for good composition held by the Greeks. It was considered to be the ideal division of a surface to ensure that the picture plane is divided in a balanced and symmetrical way. The Greeks based their definition of perfect proportion on this theory.

The Golden Section was held to have a natural balance and symmetry, and, ever since its inception, geometry has played an important part in composition.

While most painters would not have full knowledge of this principle, it is inadvisable to divide a painting into two equal halves, such as sea and land: the result is monotonous and disjointed. An awareness of compositional rules will help you to create a pleasing image.

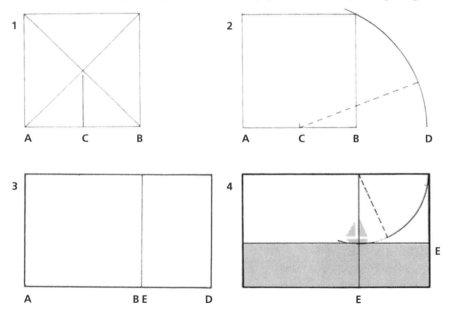

Above: *To find the sections, divide the line AB in half at C* **(1)**; *draw a radius from the top right corner of the cube to create D* **(2)**. *In the drawing* **(3)**, *lines have been drawn to create a rectangle, point BE forming the vertical section. To find the horizontal section* **(4)**, *draw a line from the top of the vertical E to the bottom right hand corner and a radius from the top right corner downward; the line and arc intersect at the level of the horizontal section E.*

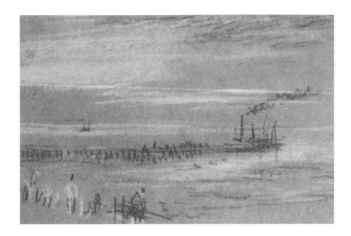

Left: *This sketch from the notebooks of J.M.W. Turner fulfills the requirements of the Golden Section. In Turner's sketch, the horizontal line of the jetty and the verticals at its far end conform to the ideal positions described in the diagrams on the previous page.*

What are the dynamics of a rectangular painting?

The majority of pictures are rectangular. Partly this is a practical consideration because paper is sold in rectangular sheets; but it is also a visual matter, as a rectangle gives a clear-cut, balanced picture area within which you can organize the elements of your painting.

A square is a balanced, self-contained shape; a rectangle with horizontal emphasis is soothing to the eye; and a vertical format is more thrusting and confrontational. However, the impact of a painting is usually more dependent on what you put into it than on its actual shape, although there are exceptions. In an elongated rectangle, the emphasis of the longest side can be a dominant factor. You would find it hard to counteract it completely by the opposing rhythms or directions you create in your composition.

As soon as you make a mark on the surface — a line, a blob, or a defined shape — this mark interacts with the overall shape of the picture. Firstly, it seems to come forward from the "background" of the paper. Secondly, it takes your eye to a particular part of the overall rectangular shape. As you add other lines, brush strokes, or color areas, they alter the original relationship and react together, forming links or oppositions. These are "abstract" interactions, which occur alongside the pictorial content of your composition.

The framework of your painting has an independent presence of its own and informs the perception of the painting.

How is the picture area divided?

When you are planning a picture, you can control the composition, regardless of its shape, by thinking of the main divisions of the picture area as forming a framework of simple shapes.

For example, in still-life paintings, you will often see that the group of arranged objects roughly forms a triangle. To create visual interest, a tall object is placed near the back of the group and other objects are spread out sideways across the foreground. The front of the group forms the base of a triangle and the tall object becomes its apex. To balance and anchor the triangle, there may be a horizontal line running behind it. This could be the edge of a table, with possibly a vertical line at right angles to it.

Once you have discovered the basic structure of the painting, you can also look at its subdivisions: how individual objects are proportioned and whether they overlap or have spaces in between.

Artists may not define a basic framework before starting to paint, or see objects as geometric shapes, but it is a useful way to start until composition becomes instinctive with experience.

It is advisable to avoid placing an emphatic shape in a way that divides the picture area in half horizontally or vertically. Often an important division falls off-center, and elements on either side of it are composed to create an asymmetrical arrangement (see *In composition, what is the Golden Section?*). This creates a balanced structure, and avoids the risk that the picture will seem so evenly balanced as to become unrealistic and uninteresting.

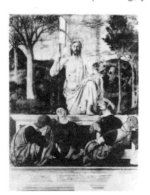

Above: *Piero della Francesca was a fifteenth-century Italian artist whose interest lay in mathematics as well as art. The triangle was the geometric base from which he worked, and is a common compositional device which is still much used, as are the circle and rectangle.*

What is meant by the picture plane?

The central problem in representational painting is recreating a three-dimensional effect on a two-dimensional surface. To do this, you regard the paper as a window, called the picture plane, behind which the spatial arrangement of the picture can be organized in layers, receding in parallel to the picture plane.

Perspective systems are a way of formalizing this layering, allowing you to suggest receding space by means of the principle of convergence. They also allow you to deal with the apparent differences in scale and proportion which will indicate where objects are located within that space. The basic guideline for perspective is the supposed horizon line, which corresponds to your eye level. Your viewpoint in relation to the subject is also very important in establishing the framework of a composition. The viewpoint can affect the mood of a painting, as well as its formal structure.

How do I scale up a rectangle?

When working from a photograph or sketch, you may want to enlarge the image, while keeping the proportions the same. This is called "scaling up."

A rectangle can be enlarged simply, without the need for calculations. This will ensure that the shape used for the finished painting is exactly the same proportion as the sketch or photograph.

You will need a set square, a ruler, a pencil, the original reference, and a sheet of tracing paper, taped over the original. First draw the bottom line, then the left vertical line. This forms the bottom left corner shared by the original and the enlargement. Place the reference in this corner and draw a diagonal line from the bottom left corner to the top right corner of the original. Extend this line to the top right *(below)*. At any point on this line you can drop a vertical to the base line and a horizontal to the left-hand vertical. This forms your new, scaled-up rectangle in proportion to the original.

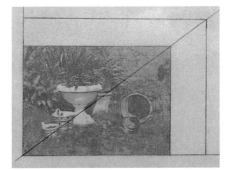

How do I enlarge a sketch?

Preliminary sketches are often drawn smaller than the finished painting. If you are working from photos, they will also need to be enlarged. The grid method is a precise way to transfer, enlarge, reduce, or even deliberately distort an image. It is time-consuming, but you can ensure accurate proportions.

You will need to draw two grids, one to go over the reference, and a second, proportionately larger, to act as a guide for the new drawing.

YOU WILL NEED

Original sketch or photo

Two large sheets of tracing paper

Masking tape

Ruler

Set square

Pencil

Colored chalk

Watercolor paper

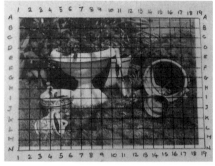

1 Lay tracing paper over original. Tape together. Draw a grid over tracing paper. Number vertical lines, letter horizontals.

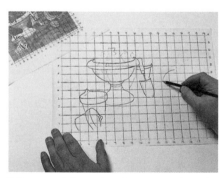

2 On second sheet of tracing paper, redraw the grid, exactly twice the size, then label the squares. Transfer the drawing from the small to the large grid, using clear, simple lines.

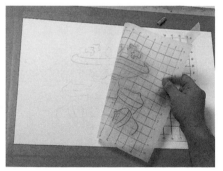

3 Rub over the back of the tracing with chalk. Tape the tracing to watercolor paper, chalk side down, and redraw over the existing drawing; the lines are transferred in chalk.

How do I use a viewfinder?

For most people, good composition requires a good deal of practice and experience. When we look at a complex subject like a landscape, it can be difficult to select a balanced composition from the vast array of shapes and colors.

A cardboard viewfinder is a great help in such cases. By moving around the subject and looking through the viewfinder, you can home in on particular sections of the scene and isolate them from the overall view. The edges of the viewfinder act as a kind of picture frame. By placing a definite border around what you select, you will find it easier to examine the interplay of shapes and masses.

A viewfinder also enables you to see the subject in terms of areas of light and dark value. Viewfinders made from a neutral-colored cardboard also act as a convenient indicator of middle value.

How do I make a viewfinder?

Cheap and easy to make, the cardboard viewfinder is a simple but invaluable piece of equipment. Choose a neutral-colored cardboard such as buff or pale grey, which provides a middle value from which you can assess other values.

YOU WILL NEED

Sheet of neutral-colored card,
6 x 8 in. (15 x 20 cm)
Pencil
Steel ruler
Craft knife

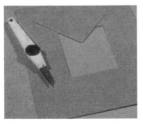

1 Draw a rectangle 6 x 4 in. (15 x 10 cm). Cut out the window following the steel ruler, to keep the edges crisp.

2 Make sure that the window is centered within the frame, with borders of equal width on all sides.

3 Close one eye, look through frame. Move it around, or try an upright image, until the subject is framed well.

What are balance and counterbalance?

One of the most important goals in composing a painting is achieving visual balance. In other words, the various elements that make up the image — lines, shapes, colors, values, and textures — must be arranged with care, so as to create a harmonious result.

Throughout the centuries, artists and critics have put forward innumerable theories about what makes a successful composition. But it was the ancient Greek philosopher, Plato, who expressed most succinctly what good composition is all about. Plato stated quite simply that *"composition consists of observing and depicting diversity with unity."* By this he meant that a picture should contain enough variety to keep the viewer interested, but that this variety must be restrained and organized if we are to avoid confusion.

Plato's observation sums up, in fact, the dilemma that faces us each time we begin composing a painting. For though the human eye is drawn to stability, order, and unity, it is also attracted by freedom, diversity, and the element of surprise. The challenge for the artist lies in striking the right balance between these opposite attractions.

Asymmetrical composition

The most obvious way to achieve balance is through a symmetrical composition, in which elements of similar value, shape, and size are used together in almost equal proportions. Although at times such a structure may serve a concept

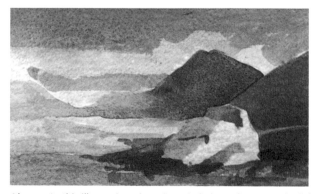

Above: *In this illustration, there is an imbalance between the left and the right halves. The mass of mountains and rocks on the right has great visual weight, with its strong color and value contrasts, whereas the left half of the picture is virtually empty. The scales (right) demonstrate this imbalance.*

well, for most purposes too much symmetry results in a rather static and uninspired design, lacking in the element of diversity that Plato mentioned.

Counterbalancing elements

For most artists, the way to achieve diversity within unity is to create an asymmetrical composition, in which features that are inherently different but of equal interest are arranged so as to counterbalance one another. An asymmetrical composition succeeds in creating a sense of equilibrium, while at the same time allowing a contrast of shapes, colors, and values that lends vitality and interest.

Asymmetrical composition is often compared to a pair of old-fashioned weighing scales, in which a small but heavy metal weight on one side can balance a much larger pile of fruit or vegetables on the other. Think of the shapes and masses within your composition as "weights" to be balanced and counterbalanced until an equilibrium is found. Remember, it is not only size that gives an object visual weight — strong color, shape, texture, or value will attract the eye when used as a contrasting element, even in small amounts. For example, a large area of light value can be counterbalanced by a small area of dark value that has more visual weight; and a large area of cool color can be offset by a small amount of intense color that creates a strong focus, despite its size.

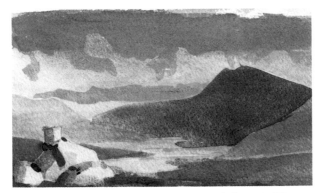

Above: *This version shows how an asymmetrical composition can create visual interest, while retaining balance and unity. The artist has enlarged the distant mountains and included only the foreground rocks on the left. Looking at the scales* (right) *we have a small mass of light value on the left that has enough visual weight to counterbalance the large mass of dark value.*

Does a picture need a focal point?

The nineteenth-century English artist and writer John Ruskin was once asked if a picture needed a focal point. His reply was definitive: *"Indeed it does, just as a meal needs a main dish and a speech a main theme, just as a tune needs a note and a man an aim in life..."* In other words, a picture should have one strong center of interest to which the viewer's eye is drawn, the point which holds the message of the picture.

Of course, many paintings do not have a center of interest, but these are usually abstract designs in which the artist sacrifices dramatic interest for the overall unity of pattern or texture. In representational painting, on the other hand, the lack of a center of interest leads to an incomplete feeling.

When planning the compositional arrangement of the painting, your first question should be: *"What do I want to emphasize, and how should I emphasize it?"* For example, in a portrait the center of interest is normally the sitter's face, whose expression conveys his or her personality. In a still life, the center of interest might be a vase, with the other objects playing a supporting role.

Tonal contrast

There are several devices that the artist can use to bring attention to the center of interest, such as placing more detail or texture in that area, or more intense colors, or contrasting shapes. But the most dynamic attention-getter is tonal contrast. It is well known that light areas stimulate the nerve endings in the eye and appear to expand, whereas dark

Left: *This seascape has a few key physical features to hold our interest. But the sea and the sky could have been made to look more interesting than they are here; the painting has no obvious focal point, and out eyes dart from one area of the picture to another, unable to settle on one place.*

areas absorb light and appear to contract. Therefore, by placing the lightest light and the darkest dark adjacent to each other at the center of interest, you create a visual tension, a "push-pull" sensation that attracts the viewer's eye and holds his or her interest.

Creating a focal point

More often than not, the subject that you want to paint won't have an obvious focal point — it's up to you to create one. This applies particularly to landscapes and seascapes, in which the sheer magnitude of a panoramic view makes it difficult to focus your attention toward a specific point. When you are looking at the real thing, your eyes can happily roam at will over the scene without resting on any particular point,

and this won't detract from your enjoyment. But it's a different matter when you take all that detail, color and movement and "freeze" it on a sheet of paper. Here a viewfinder may help.

Remember that there should never be more than one major center of interest in a painting. If there is more than one dominant area, the message becomes diluted and the picture loses impact. Even if the picture contains multiple subjects, the composition needs to be controlled so that one subject or area commands more attention than the rest. If a landscape scene has two foreground trees of equal size, they will compete for attention. Therefore, you will have to deliberately reduce the size of one tree to lend more importance to the other and draw the eye to it.

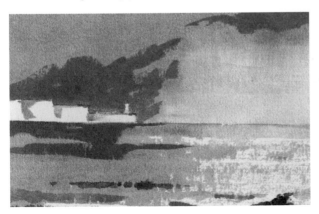

Left: *The same scene, but with one improvement. Our attention is caught by the light shape of the cliffs against the dark cloud. The artist has placed the lightest and darkest values next to each other, and this sharp contrast makes an arresting focal point. The dark foreground wave acts as a counterpoint to this.*

Are there guidelines to being selective when composing a painting?

Whatever your subject or style of painting, you do not have to include everything you see before you. Part of the process of composing a picture is choosing key elements and discarding unimportant or distracting features. This could mean eliminating whole objects — bushes or parked cars in a landscape, for example. It also means ignoring the kind of detail that is inappropriate to the scale of your painting, or lost over distance — when you see a grassy field from afar, you see only broad areas, not the individual blades of grass, but even if it is near by, you still don't necessarily have to grapple with the details.

When you are deciding what and what not to include, remember to consider the pictorial value of the elements. A telegraph pole may seem superfluous to the content of your landscape, but it could provide a useful vertical emphasis.

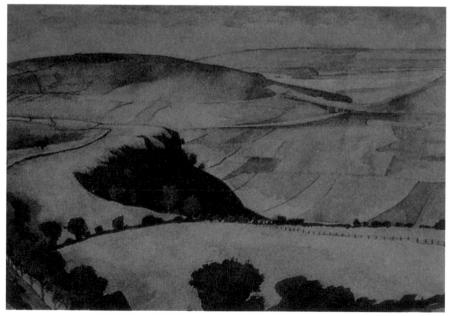

Above: *The structural harmony of* Barton Rock, *by Rosalind Cuthbert, is echoed in the gentle color variations set against patches of deep tone.*

Think about how each component functions not only as part of the "reality" of the painting, but also its contribution to the whole composition.

If you find it difficult to decide what to include in your painting, try breaking down your view of the subject into simple, manageable shapes and paint them in flat areas of color. When you see how they work two-dimensionally, you can move on to selecting more detail from the information in front of you and build up the composition gradually. Using a viewfinder may help (see *How do I make a viewfinder?*).

When composing a picture, what impact do the outer edges have?

For centuries, the conventions of composition demanded that the "events" of a painting should take place entirely within the picture rectangle. While dynamic lines and shapes might be arranged to lead the eye around the picture, the composition was usually organized in ways that kept the viewer's interest within the painting, and no vital element would be cut off at the edges. A figure group might be framed by trees which run off the sides of the painting, for example, but the trees are not important in themselves; they form an archway which concentrates the viewer's attention on the central subject.

With the advent of photography in the mid-nineteenth century, artists discovered that informality could be highly effective in a composition. "Snapshot" images began to appear in paintings where some of the visual information was indistinct and out of focus. Photographs sometimes cut off objects and people in strange ways, and painters began to appreciate how they could use the same kind of effect. They discovered that allowing figures and objects to be cut off by the edges of the picture had the effect of drawing the viewer into the scene. It also created a more complex dynamic effect between the picture area and the shapes within it. These pictorial devices were first exploited by the Impressionists, and have become widely used in twentieth-century painting.

Part of your process of selection in deciding how to frame your subject should include where to place the outer edges of your painting in relation to the subject. It is not essential to include all the objects that are to be portrayed in their entirety.

What does "taking a viewpoint" mean?

The varying viewpoints that you can take reveal different aspects of the subject's mood and character, and present alternative options on composition.

High viewpoint

In terms of composition, this is useful — the high view puts lots of information on display and reveals how the subject is spatially organized. It can, however, create a detached, superior impression, especially with human subjects, as it provides an unfamiliar view of people. If you use an imaginary high viewpoint for a landscape, you will need to work out the formal perspective arrangement.

Normal eye level

This is your actual experience of objects seen from a normal sitting or standing position. It provides a straightforward and familiar view. The information works from front to back of the subject so it is important to organize the depth of your picture effectively.

Low viewpoint

This is an unfamiliar view and can create an unusual composition. Things close by seem large, but they may obscure other interesting features.

Frontal viewpoint

This is a direct view which sometimes seems confrontational. It simplifies spatial concerns, as the objects usually recede one behind another, but the painting can appear formal and unsympathetic.

Oblique side view

This unusual viewpoint suggests that you are glancing in on your subject. The way important shapes relate to the picture

Above: *A view of a tennis court from a window* (top) *shows an overall perspective that seems normal and acceptable. The higher viewpoint* (center) *exaggerates the recession and brings the detail of the tree branches into the foreground. From ground level* (bottom) *the horizontality is emphasized, with the fence becoming the prominent feature.*

rectangle can create great dynamism and impact but should be used with care.

Distant view

The character of the subject influences the effectiveness of a long view. In a landscape, the distant viewpoint can help you to express its spaciousness. If you position a figure far away, it enables you

to show it in an exciting context, but it may make the subject seem insignificant.

Close-up view

Homing in on the subject helps you to create a detailed statement. This kind of view compels the viewer to respond actively to the picture. It can, however, create a feeling of unease.

What are perspective and simple perspective?

Perspective

Perspective is the representation of depth, solidity, and spatial recession on a flat surface, in drawing and painting. Linear perspective is based on a principle that receding parallel lines appear to converge at a point on the horizon line. Aerial perspective represents the grading of tones and colors to suggest distance which may be observed as natural modifications caused by atmospheric effects such as mist.

Simple perspective

The whole system of perspective is founded on one basic tenet which can be readily observed by eye: the apparent decrease in the size of objects as they recede towards the horizon. If the objects in question are a series of simple cubes, then it follows that the side planes will appear smaller the further away they are. And to make this happen the parallel lines have to come closer together (a geometrical impossibility but an optical fact) until they meet on the horizon line.

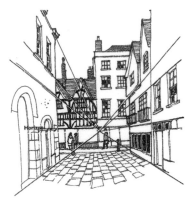

Left: One-point perspective is the term for the simplest kind of perspective, in which all the receding horizontal lines meet at the same vanishing point (VP). In this case, the artist has drawn from the middle of the street, so the vanishing point is in the center of the picture. If he had been further over to the right, it would have been somewhere on the left. Often it is outside the picture, so you have to estimate its position.

What is meant by the vanishing point?

The golden rule is that all receding parallel lines meet at a vanishing point (VP), which is on the horizon. This sounds simple, but where, you may ask, is the horizon? It is easy enough when you are looking at an expanse of sea or a flat landscape — the horizon is where the land or sea meets the sky — but where is it located when you are in the middle of a city and can see nothing but houses? The answer is that the horizon is exactly at your own eye level, and this is what determines where the lines will converge.

Normally, when you are sketching or simply walking around, your eye level (horizon) will be lower than the tops of the buildings, so the horizontal lines of roofs and high windows will appear to slope down; but if you choose a high eye level, for example looking down on a group of houses from the top of a hill, the horizontal lines will slope upward.

Establishing the vanishing point is the essential first step when drawing and painting buildings, because it gives you a definite framework on which to work — the angle of every horizontal, from the top of a roof to the bottom of a door, is determined by it.

If you are in the middle of a street, with a row of houses on either side, the vanishing point is directly in front of you and at your eye level. First mark the horizon line and then lightly rule as many lines as you need to establish the diagonals of rooftops, window lines, door frames, and so on.

If you are viewing at an angle, you will have to work out the position of the vanishing point. Mark in the horizon as before, draw in the nearest vertical to the required height, and then assess the angle of the rooftop by holding up a pencil or ruler in front of you. Extend this line to the horizon, and you have your vanishing point.

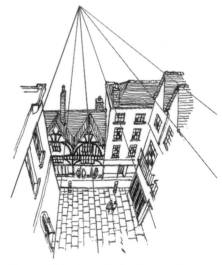

Above: *High viewpoint is still one-point perspective, but because the scene has been viewed from above, the receding lines slope upward to the vanishing point instead of down. When you are working on location, take care not to change your viewpoint, as this immediately alters the perspective.*

What is complex perspective?

Once you have grasped the principle of one-point perspective, two-point — which is what you have when you look at a building from an angle — presents no problems. The rules are the same, and it is an easy matter to plot another set of receding parallels.

But you can't always do this when you have a multiplicity of vanishing points, which is often the case if you are painting a street scene, particularly in an old town. Houses are bound to be at different angles because streets will twist and turn, intersecting one another at seemingly random angles.

Although the rules for multiple vanishing points are the same for any horizontal planes, inclined surfaces are different: their vanishing points will be

above the horizon. It is important to remember this because roofs are inclined planes, and cannot be treated like flat ones.

Trying to plot every single vanishing point would be a laborious waste of time. But this doesn't mean that you can afford to forget about perspective, and you will need to make a careful drawing. Choose a key building, perhaps the one nearest to you or that in the center of the composition. Plot the perspective for this carefully and then draw in all the other roofs, walls, and details with reference to the verticals and angles of your key.

Keep checking your drawing against the subject, making sure that all lines intersect in the right place. Make careful

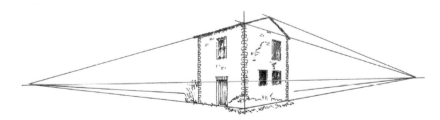

Above: *Two-point perspective: when a building is viewed from an angle, there are two vanishing points. If your eye level (horizon) is low — or you are drawing a tall building — the rooflines will slope downward very steeply. If the horizon is higher and the building is low, the slope will be much gentler. Always begin by marking in the horizon line, and then assess the degree of the angle of the roofline by holding up a pencil or ruler at arm's length.*

measurements as you work. You can do this by holding a pencil up in front of you and sliding your thumb up and down it, or you can use a ruler.

The advantage of the latter is that you can take exact measurements, and you can also, of course, use the ruler to draw lines and to make sure that verticals are true. To do this, measure the distance from the edge of your picture at the top and bottom edge. You might also find the drawing frame a helpful tool.

Don't feel ashamed of using these so-called mechanical aids, all artists employ some form of measuring system, whatever they are drawing. The drawing does not have to be completely freehand. In the case of buildings, one crooked vertical can lead to a distortion of the perspective over the whole drawing. Once you start to paint, you can be as free as you like, secure in the knowledge that you know exactly where to place the colors, and any ruled lines will quickly be obscured.

If you intend to finish a picture on the spot, it is a good idea to make the drawing on one day and paint on another. The drawing will not be much affected by changing light, but the painting will.

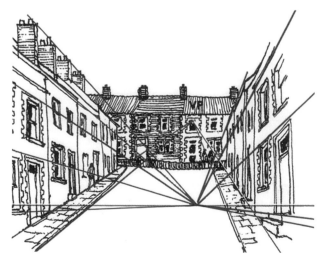

Left: *With a complex subject like multiple vanishing points, it can be difficult to know where to start. The first step, as always, is to establish the horizon line. Then mark in the vanishing points for the main buildings and draw them as carefully as possible so that you can use them as points of reference for the others.*

What is aerial perspective?

In a color photograph of a landscape, some of the greens will appear more vivid than others, to have a brighter hue. You may notice that the brightest colors are in the foreground, where the contrasts in tone are also the strongest, those in the background tending to merge into one another and become barely distinguishable in some places. An understanding of this phenomenon, which is called aerial perspective, is vitally important, and especially so for the landscape painter.

As a landscape recedes into the middle and then the far distance, objects appear much less distinct and become paler and bluer because the light is filtered through dust and moisture in the atmosphere. It is possible to suggest distance and recession in a painting by using this kind of perspective alone, and such effects are easier to achieve in watercolor than in oil: a pale, flat wash can be put on and then the tiny differences in tones suggested by just a dab or two of barely tinted water.

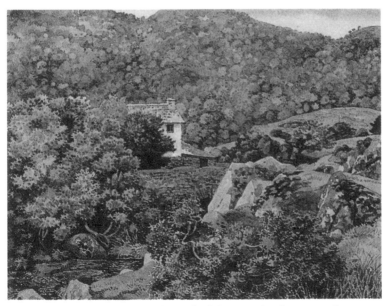

Above: Fell and River, *Juliette Palmer. The foliage on the distant trees becomes progressively bluer, with much softer detailing of foliage than is used on the foreground trees.*

How important is sketching?

Sketching plays as important a part in the making of a watercolor as in any other form of art, and any aspiring painter should bear in mind its potential. Apart from the sheer pleasure of making rough drawings, sketching serves the purpose of making notes for future reference, which is important where the light is changing rapidly or you wish to record moving figures or dramatic visual images.

Sketchbooks are available in a wide range of shapes and sizes. Spiral bound books are useful for tearing off pages.

Some drawing materials are less well adapted to smaller-scale sketching work. Bamboo, pens, and oil pastel, for instance, are fairly clumsy tools, ideal for certain tasks but not generally for making rapid notes. It is, as always, up to the individual artist to decide what best suits his purpose; whatever combination of materials is eventually chosen, starting to sketch with a ballpoint pen, an HB pencil, and a small sketchbook will allow for a surprisingly wide range of possibilities.

Left: *Color can be added to a sketch as a means of enlivening and extending information and interest. Even black can be used to create a variety of effects. In this example, fine, linear drawing is used to describe the nude figure form while hatching and stippling give a completely different quality to the seated, dressed figure. The artist has been concerned with the positions of the figures on the page, placing them so that the maximum contrast is pointed up between the horizontal and vertical poses.*

Does the size of a sketch affect the size of the painting?

Sketchbooks are obtainable in all types and sizes, and it is up to the preference of the artist and his situation as to the size of the sketch. Sketches can easily be scaled up to draw the initial outlines of the painting so the size of the sketch is unimportant to the finished result.

The information recorded is the crucial element of a sketch. A summary of the color notes, tonal values, and details can be built up in a sketch with simple brushstrokes and fluid hand movements.

The sketch of a billiard player *(below)* is one of a series of studies made in preparation for a larger painting in a different medium. The sketches recorded notes for the artist on color, tone, and form in the room as a whole and detail of different positions of figures around the table.

It is wasteful to use good quality, heavy watercolor paper for such studies, but in sketchbook work the paper cannot be stretched and is bound to wrinkle slightly. This does not affect the usefulness of the material when the information is later used as reference. However, in order to minimize the wrinkling, the color should be applied as dry as is practicably possible.

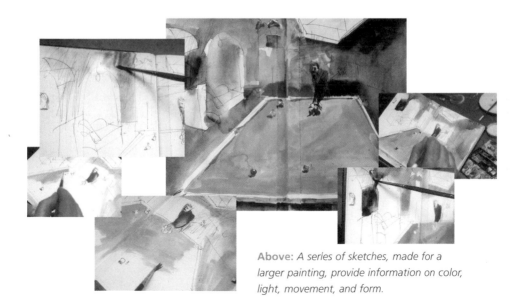

Above: *A series of sketches, made for a larger painting, provide information on color, light, movement, and form.*

How do I start making a painting?

There are two main approaches to developing a painting. You can "work it up" from photographs and sketches done on the spot, or you can paint it directly from life. There are important benefits to the direct approach.

You will acquire the ability to translate a three-dimensional scene into the two dimensions of your pieces of paper. You will develop skills in composition, because only very rarely will you find the perfect composition without the necessity for modification, alteration, or simplification. And you may see more possibilities in your subject than a

photograph would reveal. When you are sketching, you are inevitably studying your subject carefully and viewing it from different angles. Even if your efforts do not result in the ideal painting, it will have been a valuable learning exercise.

The bare minimum you need to make a start, and jot down visual ideas, is a sketchbook and pencil, together with a small watercolor box to enable you to add color washes to your drawing. You can then progress to a watercolor pad, producing more complete paintings from life.

A sketch can become a finished work in its own right, like a camera catching a fleeting light effect or the expression on a face.

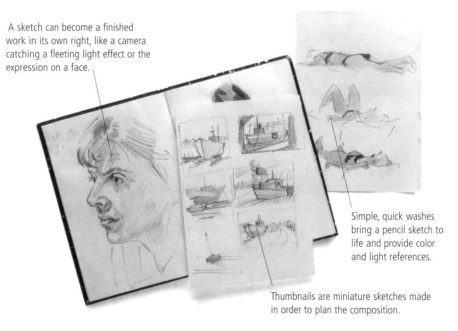

Simple, quick washes bring a pencil sketch to life and provide color and light references.

Thumbnails are miniature sketches made in order to plan the composition.

How do I use reference material?

Paintings do not, of course, have to be done from life: many fine landscapes are painted in the studio, and excellent portraits are done from photographs or drawings or a combination of both.

Few good paintings, however, are done from memory. Even professional artists, who are trained to observe and assess, and are constantly on the lookout for visual stimuli, make use of reference material for their paintings. These may be sketches or photographs, sometimes even picture postcards. You may think that you remember a scene very well, but you will be surprised how the details escape you as soon as you sit down to paint it. It is therefore wise to amass as much reference material as possible, even if it seems to be much more than you need.

Carrying a sketchbook is strongly recommended — it encourages analytical observation, which is quite different from just looking and admiring. The trouble with sketches is that it takes experience to know which particular aspect or detail of a scene you will want to refer to later. Also, unless you draw with assurance, you may find that you have failed to capture the essence of what you wished to record — like taking notes and finding you cannot read your own handwriting.

The camera is useful as a note taker, but it should not be regarded as any more than this, as it distorts perspective and flattens color. Take photographs, and when you begin the painting try to use them constructively, together with your own recollections of the scene.

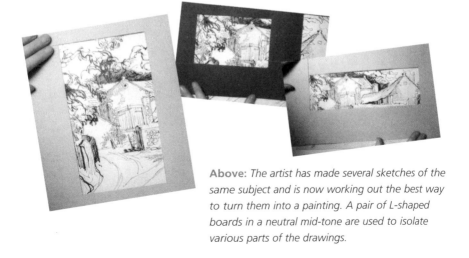

Above: *The artist has made several sketches of the same subject and is now working out the best way to turn them into a painting. A pair of L-shaped boards in a neutral mid-tone are used to isolate various parts of the drawings.*

Can I work up a subject using photographs?

Yes, a range of photographs can be collected as a form of reference library, which you can draw on for ideas. Never try to copy a photograph slavishly, as this distorts perspective and deadens tones.

Photographs are also ideal for capturing short-lived effects, such as light falling on to a still life. They make a useful back-up reference for painting.

The camera is perfect for note-taking on scenery, when you don't have time to stop. Fast action, which might otherwise be missed, can be easily frozen with the camera.

This still-life photograph records the moment the sun streamed through the window.

Photographs can provide valuable back-up notes on scenery.

Fast-action images can be captured on camera.

What are thumbnail sketches?

Thumbnails are quick sketches which record useful information for the artist. Before starting a painting, spend some time making simple pencil sketches, drawing the basic shapes and directional lines you can see in your subject.

Start by making a framework of connecting lines that contain the overall shapes, then start to break down the large areas into small sections, paying attention to the relative height, width, and depth of different elements in your subject, the interaction of straight lines and curves, and the links between shapes in different parts of the picture.

When you have made a variety of quick sketches, play around with the size and proportion of the picture. Try drawing a rectangular frame around each sketch to increase the background area or push the edges of the picture closer into the subject, perhaps allowing important shapes to be cut off at the sides, top, or bottom of the frame.

1 The picture frame encloses a conventional view with vertical and horizontal stresses evenly balanced.

2 Moving into the subject, the artist makes the vertical stress more central and the background more busy and active.

3 Featured so closely, the tree becomes an abstract shape that divides the background and breaks up the balance.

What should be considered when working from sketches?

Begin by spreading out your store of visual references made on the spot, and then make a few more sketchbook studies to plan the composition and structure before beginning the painting.

Consider trying out color combinations at this planning stage. Working in a sketchbook gives you more freedom to make mistakes. You can construct the painting in your sketchbook, learning through trial and error, so that once you start painting, you will know exactly what you are doing.

All of the most important aspects of composition, including the relative sizes and positions of the elements, and the distribution of tones, are established at this early drawing stage.

If you are sketching in pencil or ballpoint pen, make descriptive color notes to help you when you come to work out the painting.

3

BASIC WATERCOLOR TECHNIQUES

How can I map out the early stages of a painting with washes?

Washes can be used to map out the early stages of a painting, either working over a drawing or simply shaping the composition through brushstrokes.

The fluidity and transparency of watercolor in a medium wash provides a foundation for further glazes and detail, enabling you to build up the painting with a series of washes like luminous veils of color.

Working from light to dark in progressive layers creates an illusion of space, similar to the effect of objects receding in a landscape.

Technique study: Contrasting tones

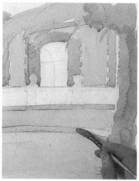 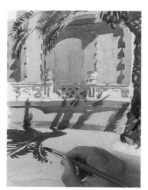 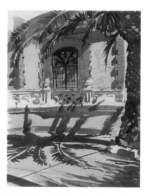

1 Clearly outline the different areas in pencil. Keep initial washes pale and of similar tone throughout. Use sap green for the palm leaf, burnt umber for the trunk, yellow ochre and burnt sienna for the walls, Payne's grey mixed with violet for the foreground. Leave the parapet white.

2 The next set of washes is darker. Paint the leaf fronds with a mix of Payne's grey and sap green, and mix burnt sienna and violet for the brickwork shadows. Use Payne's grey and burnt umber for the trunk. Add parapet detail in cerulean blue and the floor shadows in violet.

3 Fill in with the final washes: burnt sienna on the brickwork and on the trunk, sap green and Payne's grey in the leaves, violet in the window. Paint the shaded leaf fronds and the window ironwork in Payne's grey. To finish, paint the fine brickwork detail in burnt sienna with a rigger.

Technique study: Variable washes

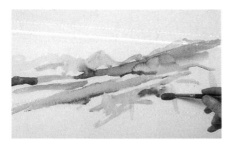

1 No drawing is done for this painting. Lay several adjacent washes and allow the colors to mingle where they meet. Use cerulean blue for the mountains, then monestial green for the middle distance, and finally yellow ochre, raw umber, and burnt sienna in the foreground.

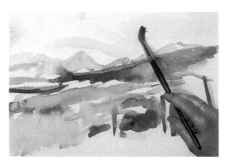

2 Work fairly fast, applying the next wash before the previous one has dried. Apply a pale wash of cerulean blue for the sky, a second wash of monestial green in the middle ground, and Naples yellow in the foreground. Paint the fence in Prussian blue.

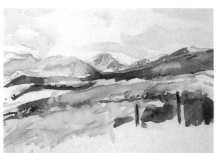

3 Add detail to the mountains using more concentrated cerulean blue. Brush Prussian blue mixed with yellow ochre across the middle, then apply it in small dabs to suggest rough vegetation. The result is a loose, almost abstract painting that uses an exciting range of brushwork.

Are there variations for flat washes?

Here are some other ideas as to how flat washes can be used. Overlaying washes builds up color gradually, allowing the variation in tone to provide detail. The resulting color is rich and provides three-dimensionality.

Technique study: Overlaying flat washes

1 This precise drawing matches the style of the rest of the painting, with its pure washes. Use a medium brush to paint the first washes of yellow gamboge, sap green, and a mixture of rose madder genuine and cobalt blue. Soften the highlight on the teapot while wet.

2 When completely dry, go over all the objects with smaller washes of the same colors, defining their darker tones. Use a pointed No. 2 brush for the smaller areas, carefully painting accurate ellipses in the saucers.

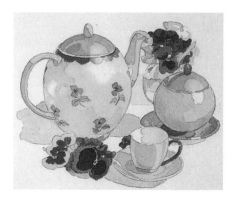

3 Using very small washes, paint in all the decorative detail on the teapot and flower stamens. The limited palette used here is very effective in producing perfect color harmony, and the placement of the objects produces a well-balanced composition.

Technique study: Simple washes

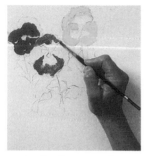

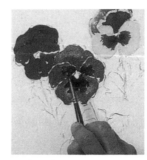

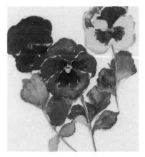

1 Paint the three main flower areas in alizarin crimson, ultramarine with Winsor violet, and cadmium yellow pale, using a No.6 brush. Paint on a dry surface to retain crisp edges, but allow slight fluctuations of color.

2 When dry, paint sepia on the red flower to separate the petals, Venetian red and crimson on the yellow, and concentrated ultramarine on the blue/violet flower. While these are drying, apply yellow to the center of each flower.

3 Paint the leaves and stalks in variations of cadmium yellow pale and ultramarine. These variations in color and tone prevent the plants appearing flat and unrealistic, and place them in a three-dimensional space.

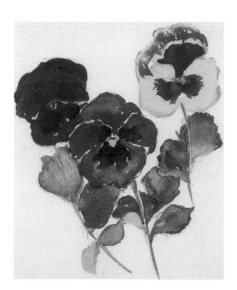

Left: *Apply yellow to the center of each flower while the background is damp, so that the colors blend slightly.*

ARTIST'S TIP

Purists claim that more than three layers of wash spoils the quality — something to keep in mind should you need to strengthen the color or darken the tone of the wash.

How is the small wash used?

The term "wash" is misleading, implying large areas of paint, but a wash may be no bigger than a single brushstroke.

Small washes are the building blocks of a painting. You can use them individually to describe shapes or apply them collectively to build up a complex picture. You can also overlap them to build up tones and enrich colors. They may be geometric and precise in shape or comprise irregular and free-flowing forms, as the subject requires.

What is meant by interlocking flat washes?

Washes of all sizes can be interlocked like a jigsaw to create a scene. This painting is done with a progressive build-up of paint, from large to small areas, which collectively read as a group of three-dimensional objects. The interplay of lights and darks and interesting patterns all play an integral part. Draw the ellipses and curves with special care, as these make up the bulk of the shapes.

1 With a 1 in. (2.5 cm) hake, lay a pale wash over the whole area, hinting at fluctuations in tone and color with light cadmium red, yellow ochre, indigo, and ultramarine. When dry, apply another overall wash, this time working around the palest objects.

2 When the washes are dry, use the medium brush to paint the objects on the top shelf, with ultramarine, indigo, permanent rose, and violet. Use a fine brush to paint the patterns.

3 Reserving white paper for the lightest areas, paint the remaining objects with simple flat washes. Paint the oranges with Indian yellow, dropping in a small amount of alizarin crimson. Add detail with small, understated touches.

4 Paint the shadows under the shelves and behind the objects in light red with a little indigo. They help to outline other objects with interlocking shapes.

5 This painting has been achieved almost entirely with simple flat washes, using very little wet-in-wet blending, except on the first wash. The result is delightfully fresh and bright, including exactly the right amount of detail and creating many exciting patterns and shapes to interest the eye.

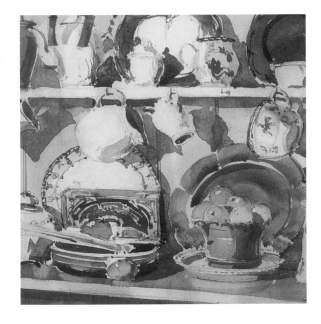

How do I use large flat washes?

This type of wash acts as a background or underpainting to be worked into while wet or dry.

A large flat wash, applied skilfully, looks surprisingly fresh and luminous but is deceptively tricky to get right, requiring practice using different brushes, paper, and dilutions.

Use a heavyweight or stretched paper and a large mop brush: a 1 in. (2.5 cm) flat or similar, works best. Working fast with the board tilted slightly toward you, load your brush and, with sideways strokes, go back and forth across the paper. Overlap each stroke slightly to pick up any excess fluid and prevent an edge from forming. As soon as you finish the wash, lay the board flat so that the paint doesn't run and cause ripples to form.

Are there other uses for large flat washes?

Large washes are not only useful for providing background color or underpainting. Working carefully, you can skim over part of an almost finished painting with a large wash to soften and unify the underlying image. This is especially useful if you want to throw a whole section into shade, as demonstrated here on the unlit wall, or perhaps on a sunlit garden scene.

1 Using a 2B pencil, sketch in the room. Pay careful attention to perspective. When you are happy with the drawing, use cobalt blue and a fairly large, round brush for the first wash. Leave it to dry.

2 Paint the floor with a mix of cerulean blue and a little Payne's grey. Carefully follow the outline, and keep the tone even throughout.

3 The right-hand wall is a darker tone because the light from the window is falling on the left-hand wall, so give it a second wash of cobalt blue. Mix enough paint initially and work fairly fast so that no hard edges form.

4 Paint the side table in rose madder genuine. Mix that with cobalt blue for the fine detail on the curtains and the flowers. Once the wall has dried, you can paint the inside of the window with cobalt blue.

5 Paint the armchair with a flat wash of carmine, omitting the legs and cushions. Use the carmine paint fairly thickly for the patterns on the rug, to leave texture resembling the carpet weave.

ARTIST'S TIP

A 1 in. (2.5 cm) wash brush will usually suffice for the larger washes. For fine detail, a rigger or No. 0 brush is suitable, and for in-between work a round No. 10 with a good point will do.

6 Paint a second wash on the shaded part of the chair and add the detail of the corner of ceiling. Paint the cushions in yellow ochre. Paint shadows with ultramarine and Payne's grey paint.

What is a graded wash?

From the gentle graduations of the sky to the varying colors in the skin of an apple, subtle changes in tone and color are all around, and a graded wash — that is a wash that fades from dark to light — is ideal for capturing them. However, the watercolor must be properly controlled because you only get one chance when applying a large area of wash.

Plan and mix all the colors in advance. If you prepare sufficient paint, you won't need to wet the paper before painting because you'll be able to work fast enough to prevent any streaks from forming. Working on dry paper in this way means that the colors will be more intense after they have dried.

What is a variegated wash?

A rainbow or sunset are typical examples of a series of colors merging into one another. This is something you can use a variegated wash to achieve in your painting. This technique utilizes watercolor's natural ability to blend one color with another.

Many colors can be gently brushed on in a controlled way, or randomly dropped into a damp wash; the sponge-like paper will retain the dampness long enough for the different colors to seep into each other. The brushwork is only the first step — the rest is left up to the paint and paper. Don't use too much water, as this will be too difficult to control, and a lot of the pigment will drain away on drying.

While the paint is drying, don't add more color or the gentle tones will be disrupted. Color-mixing also occurs on the wet surface so keep your application fresh with limited colors.

ARTIST'S TIP

Attractive efforts can be achieved by deliberately allowing the paint to flood in the middle of a wash, by introducing blobs of strong color to a paler wash while the paint is damp, or by laying one wash over a dry one, producing slight granulation of color. The effects can be unpredictable, but it is satisfying work, turning the results to your advantage.

How do I create a gradual transition of color?

To achieve a gradual, even reduction in tone, you should first lay down the darkest tone, then systematically dilute the paint with each stroke by adding water. Having several premixed dilutions to hand will simplify this. You can progress from light to dark or vice versa. It may be necessary to rework weak areas, adding or subtracting paint.

You can do this immediately or wait until the paint is dry, and then go over it with another wash or a damp brush to lift out color, as required.

To blend two colors, premix both, then paint one alongside the other, and work one into the other with several strokes. Where the two colors mix, a third color will form.

Technique study: Graduated wash

1 Mask the windows with masking fluid. Then paint the sky, brushing a band of blue across the top, followed by yellow ochre, burnt sienna, and finally Payne's grey, blending each color with the one before. Take the colors across the outline of the building.

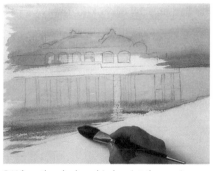

2 When the sky has dried, paint the sea in bands, beginning with yellow ochre, then cadmium red, and finally cobalt blue. (Mask out the sun's reflection first.) Use a drier brush for the foreground blue in order to leave patches of white, then apply a few streaks of darker blue.

How is a variegated wash used for underpainting?

Variegated washes make an interesting background treatment for many subjects which then need just a little brushwork to give them definition. Since the paper is pre-wet to accept the initial paint, you can use a medium decorator's brush or sponge to speed up the painting process. After you have dropped in the paint and it appears to have spread enough, use a hair dryer to arrest the process.

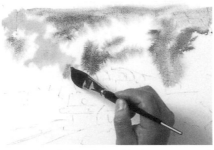

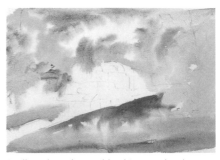

1 Wet the whole surface with clean water, and drop in Payne's grey for the sky, cadmium yellow, terre verte, and sap green for the trees and foreground, and violet for the bluebells.

2 Allow the colors to bleed into each other and even partially bleed into the train area. The pencil lines should still be partially visible. Tilt the board toward you lightly, and the colors will run downhill a little. When the blending is sufficient, speed up the drying process with a hair dryer.

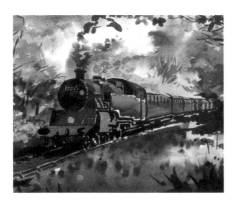

3 Do the underpainting for the train and rail track in simple flat washes, allowing a little blending on the track and rear carriages. Suggest mid-tones on the trees. Paint the darker areas on the train and trunks of trees, using a No. 5 brush. Dab ultramarine on to the foreground to suggest bluebells, spraying on water to soften the effect. Finish the rear of the train using a paler mix of colors. Paint the foreground leaves and track. Finally, paint in the smoke using diluted indigo.

Are there variations for variegated washes?

Variegated washes also work well as the main focus of the painting, to reflect the way that colors merge in nature, such as sunsets, rainbows, or sea scenes.

You may prefer to apply the main wash with a sponge, and then touch in the other colors with a brush on to the still-wet paint.

Technique study: Multicolored wash

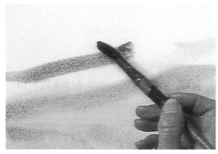

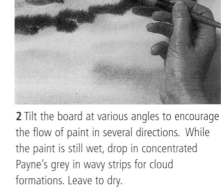

1 Wet the picture area with clean water, then paint in new gamboge in wide, horizontal brushstrokes with the brush fully charged. Immediately follow this with bright red and alizarin crimson painted in some remaining white areas. Paint Antwerp blue in the white areas at the top and bottom.

2 Tilt the board at various angles to encourage the flow of paint in several directions. While the paint is still wet, drop in concentrated Payne's grey in wavy strips for cloud formations. Leave to dry.

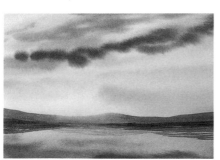

3 Paint the distant horizon and water ripples with Payne's grey. This simple strip of paint effectively separates the water area from the sky, making sense of the previous washes and thus completing the painting.

Is there a variation of use for small variegated washes?

Small variegated washes can also be used as body color to create a subtle, blending, three-dimensional effect.

Don't try to add more color as the paint is drying, otherwise the gentle tones will be disrupted.

1 With the two vegetables sketched in, lay a loose wash of Winsor yellow on the onion. While this is wet, add venetian red and raw sienna with a little burnt umber around the edges, to suggest roundness.

2 When the onion has dried, use the burnt umber to paint the curved vertical lines of the skin. Paint the turnip with an uneven wash of Naples yellow. While this is wet, drop cobalt violet on to the top half, and add into that a little raw sienna.

3 Wet the surrounding paper to allow the color to spread outside the turnip. While the turnip is still wet, paint the leaves with a variegated mix of Winsor yellow and ultramarine. This will run into the rest of the colors, leaving no hard edges.

How do I achieve a double-overlaid wash?

1 Turn board upside down, dampen paper to prevent streaking, and paint a graded wash of alizarin crimson. When dry, turn board the right way up. Apply a graded wash of Antwerp blue.

2 While the blue is wet, dab out the clouds with crumpled kitchen paper to create a fluffy texture. Leave the paint to dry. (To speed this up use a hair dryer.)

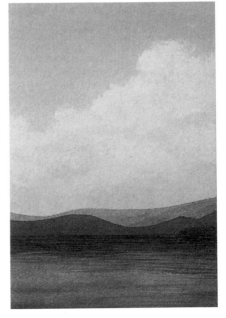

3 Paint the land in two horizontal strips of pale alizarin crimson mixed with Antwerp blue. Make second strip double the concentration of the first. When dry, re-wet the water area and drop in streaks of Antwerp blue.

4 While the water area is wet, paint in some pale red streaks similar to the blue. When those are dry, go over the area with a few more pale red horizontal strokes for the water ripples, increasing in intensity as they recede.

What is the wet-on-dry method?

Painting on to a dry surface is the most direct method of applying paint: the results are predictable, it dries quickly, the brushstrokes are easily identifiable, and the colors remain crisp and bright. Foreground images appear in sharp focus, and you can add detail with a fine brush. Working wet-on-dry also allows you to outline contours to give them sharp definition and to separate planes and objects with sharp edges.

1 This entire sequence is done wet-on-dry. Use a 1 in. (2.5 cm) hake to paint the hull of the boat in Payne's grey and light red. Paint above the hull in light red, indigo, and violet.

2 Paint the beach in burnt sienna with Payne's grey, and the red boxes in light red. Using a 0.75 in. (1.9 cm) decorator's brush, paint the background row of buildings in ultramarine.

3 With the decorator's brush, spatter flecks of burnt sienna on the beach. With a pointed brush, paint the mast with burnt sienna and a touch of ultramarine. Paint cabin with indigo.

4 Paint sky with washes of ultramarine and cadmium red and yellow, letting colors blend. Paint buoy with concentrated cadmium yellow and a little cadmium red.

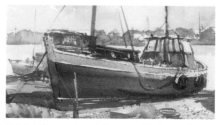

5 Paint the mast and rigging with burnt sienna and a little cobalt blue. Then finish off all the sail details with delicate touches applied with a fine brush.

What is meant by three-stage buildup?

Watercolor is an almost transparent medium. The translucent quality also dictates the best methods of application. Unlike other media, when you work in watercolor, you build up layers from the palest washes to the darkest tones. This is three-stage buildup. Careful observation and planning ensure that the white paper is reserved for highlights.

There are three overall values in this painting *(right)*: light, mid-tone, and dark (see *What is meant by keying your values?*). The palest tones are the yellow on the forehead and the pale grey — almost white — on the snout and neck. Although these colors are only small areas in the final painting, they make up much of the underpainting. To paint just the light areas light and the dark areas dark would be too fiddly, requiring extremely accurate butting-up and producing too many hard edges.

Starting with the palest wash for background, build up through mid-tones to the darkest tones, ensuring that each layer is dry before you start painting the next.

What is the proper sequence for layering washes?

A careful study of the subject will help you to decide on the proper sequence of layers. If you squint your eyes, you will be able to filter out excess detail (see *How many values should I start with?*). This will reduce the subject to simple blocks of tone to be described by each wash. Regardless of distance, lighter patches are separated out from darker patches. It's quite feasible to build up a dark tone with several washes, but it can be difficult to estimate the correct mix in one go because, as the fine pigment soaks into the grain of the paper, the wash will dry paler. Each successive layer should be painted using the wet-on-dry technique for maximum intensity.

The figure in the steps overleaf is lit strongly by the light from the window, creating some interesting tonal values.

Begin with careful observation of the subject. Do a visual tone and color breakdown, look for the direction of the light and where it falls, and analyze the shadows to see where they really are. You will need to do a great deal of simplification to get the layers right. Pale washes should go down first; they can be hidden with darker overlays, or made part of a composite buildup.

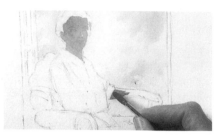

1 Make a pencil drawing. Apply a pale wash of sap green and new gamboge to window area. Paint burnt sienna on skin, leaving a white highlight on the face from the window.

2 Paint a pale cadmium red light wash on shirt. Use burnt umber for hair, leaving white highlight. Paint a darker wash of burnt sienna on face, next to the highlight. Apply a stronger wash of cadmium red light on the chair.

3 Paint a strong mix of burnt umber and ultramarine to window, leaving white for frame. Mix alizarin crimson and ultramarine to paint shirt, leaving white and some pink areas as areas of lighter tone.

4 Paint mix of ultramarine and alizarin crimson on couch. Mix cadmium red light and burnt sienna for a darker coat on the face. Paint the features with burnt sienna and ultramarine.

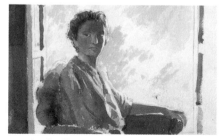

5 To finish off, add some more sap green to the area outside the window, especially next to her face. Then apply some dark linear detail on the clothing and chair.

How are dark tones handled?

Dark tones should be built up with several washes. This painting has three color stages: pale yellows; bright greens; and darks. Each stage has many overlapping washes, enabling the artist to develop the intensity of the dark areas.

1 Paint first washes: lemon, pale ultramarine, yellow ochre, and burnt sienna. These will mostly be painted over in the next stages.

2 Reserve the highlights with masking fluid. Paint green washes, initially pale, building to darker tones around the trunks.

3 Rub off masking fluid. Paint shadows. Note the sharpest contrast is where the sunlight streams from behind the trees.

Is there a method for overlaying color?

The method here is to work on a dry surface, either clean paper or dry paint. The simple mixes, usually not more than two colors at a time, and the variations in brushwork, produce a painted surface which vibrates with freshness.

1 Paint the oil lamp and the table with raw sienna wash. When dry, paint yellow ochre on lamp top and base. Build up the distinctive metallic reflections with Vandyke brown.

2 Use olive green on the underside of lamp, and Payne's grey with ultramarine for the shadow. With a much diluted wash of ultramarine, paint behind the lamp. Build up some darker tones on top and around neck. Using a fine brush and Vandyke brown, paint some thin, dark lines around base and wick hole. Sharpen up edges with the fine brush.

How do I use transparent overlays?

The transparent nature of watercolor is perfect for creating transparent overlays, allowing optical color mixing through the overlays (see *What is optical mixing?*). Each layer of paint absorbs more light, and carries detailed information in the form of textures.

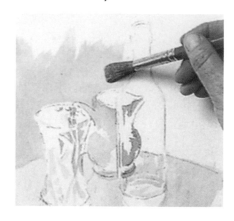

1 Use a wash of cerulean blue for the table and ultramarine for the jug. Suggest reflections on vase with emerald green and ultramarine. Apply a yellow ochre wash for background.

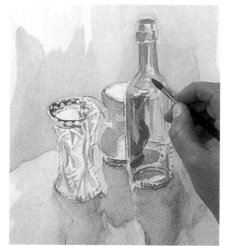

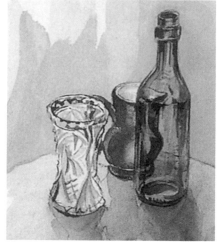

2 The multifaceted crystal vase reflects colors from all around. Continue to paint it with a combination of yellow ochre, cerulean blue, and violet, in carefully descriptive strokes. Use washes of violet, then emerald green. Paint vase and bottle reflections on the table with violet, softening edges with a damp brush.

3 Mix ultramarine and viridian, then paint detail on the bottle. To balance the tones, strengthen the ultramarine on the jug, particularly the part seen through the bottle. Paint an overall emerald green wash on the bottle, leaving a few well-judged highlights. Reinforce the violet detail on the vase.

What is the process for building up brush strokes?

The wet-on-dry technique is a versatile option, allowing precise application and a loose flowing technique, incorporating a variety of brush strokes (see *What is the wet-on-dry method?*). Use the rough surface texture of dry paper to break up the brush strokes. This effect is more pronounced on cold-pressed paper.

1 Paint the garden with olive green and terre verte, the iron railing in ultramarine, permanent rose, and caput mortuum violet. Build up the brushstrokes, leaving chinks of white paper.

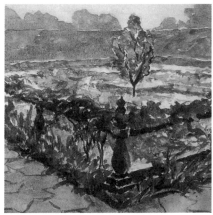

2 Painting the dark foreground tones first allows you to estimate the delicate mid- and light tones and so achieve the effect of recession. Mix cerulean blue into the original green for the lower plants. Use Indian yellow, cadmium scarlet, Winsor violet, and ultramarine for the bright flowers.

3 Work progressively into the background, diluting the brush strokes to build up the picture. Use a pale mix of burnt sienna and Winsor violet for the paving stones, and a darker mix for the cracks. Use a pale grey wash for the distant trees, and a pale neutral wash to complete the sky.

What is optical mixing?

Diluting pigment with water produces a tint of the pure color. As you overlay different color glazes, the resulting color is altered due to optical mixing, where colors are not physically mixed but laid close together, one on top of the other, so that they appear to mix. As several faint overlaid washes accumulate and combine, they result in an impressive depth of color (see *How do I use transparent overlays?*). As well as color, you can show detail in each layer, thus producing a complexity difficult to achieve in just one layer.

Building up a number of subtle layers gradually to produce deep tone is the sure-footed approach, compared with attempting to get the tone right in one go, which can increase risk of error. During the buildup, you will also be spending more time analyzing your subject matter, thereby increasing your visual understanding, and producing more pleasing color combinations and an enhanced overall effect.

In the first stage, this docklands scene is simplified as a silhouette in one continuous wash. When working this way, it is important to recognize the point at which to stop adding washes — when the correct depth of tone and color is achieved. A few selective highlights can be added later.

1 Paint a graded wash in three stages: ultramarine and Payne's grey for sky, crimson across middle, and olive green and Davy's grey for water. When dry, paint a second wash on sky. Paint the docklands as a simple silhouette.

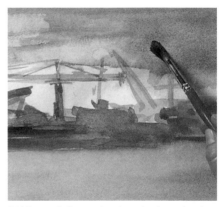

2 Using cadmium red, paint a horizontal strip at the waterline and add some fine lines for the large crane. Blend ultramarine and Payne's grey in with the red. When dry, glaze some ultramarine, yellow ochre, and burnt sienna detail, and a third wash over the sky.

3 Immediately follow with concentrated yellow ochre over the docks, letting it bleed into the still-wet sky. Continue the yellow ochre into the water to represent the warm, hazy reflection of the dock lights.

4 When the yellow ochre is partially dry, blend horizontal strips of concentrated Payne's grey into foreground. Use a more diluted Payne's grey over water, which will allow colors beneath to show. Paint grey detail over docks.

5 When dry, paint short strips of cadmium red and yellow ochre between the Payne's grey, including a strip of ochre on the right-hand horizon. Paint concentrated Payne's grey in the central area and add more detail. The gradual buildup of color results in an evocative scene of docklands at dusk.

What is meant by working light to dark?

Because watercolors are semi-transparent, light colors cannot be laid over dark. Therefore, traditional practice is to begin a painting with the lightest tones and build up gradually toward the darker ones by means of successive washes or brushstrokes (see *What is meant by three-stage buildup?*).

Many, but by no means all, artists start by laying a flat wash all over the paper, leaving uncovered any areas that are to become pure white highlights (known as "reserving"). This procedure obviously needs some planning, so it is wise to start with a pencil drawing to establish the exact place and shape of the highlights to be reserved.

The tone and color of the preliminary wash also needs to be planned, as it must relate to the overall color key of the finished painting. A deep blue wash laid all over the paper might be the correct color and intensity for the sky in a landscape, but would not be suitable for a foreground containing pale yellows and ochres.

Another variation of the overall wash is to lay one for the sky, allow this to dry, and then put down another one for the land. Both these procedures have the advantage of covering the paper quickly so that you can begin to assess colors and tones without the distraction of pure white paper.

Overpainting

When the first wash or washes are dry, the process of intensifying certain areas begins, done by laying darker washes or individual brushstrokes over the original ones. A watercolor will lose its freshness if there is too much overpainting of color, so always assess the strength of the color needed for each layer carefully and apply it quickly, with one sweep of the brush, so that it does not disturb the paint below it.

As each wash is allowed to dry, it will develop hard edges, which usually form a positive feature of watercolor work, adding clarity and crispness. Some artists find it easier to judge the tone and color key of the painting if they begin with the darkest area of color, then go back to the lightest, adding middle tones when the two extremes have been established.

ARTIST'S TIP

To create a strong and unified image, the tonal values of your painting must be carefully planned. The contrast of light against dark may prove more effective than setting color against color.

 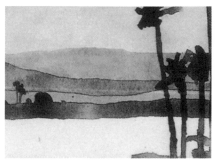

1 Lay a grey–blue wash over the sky and a slightly darker one for the distant hills.

2 Block in the details in the middle distance. Leave these washes to dry, then paint the dark trees in the foreground.

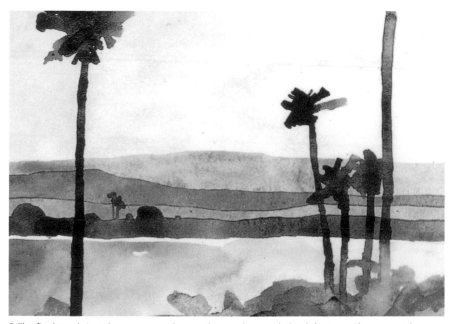

3 The final touch is to lay a green–ochre wash over the area behind the trees. The warm color creates a sense of recession as it advances toward the front of the picture, while the cool blues are pushed back.

Are there examples of layering techniques?

These paintings clearly demonstrate how the transparent nature of watercolor dictates the technique of building up washes from pale to dark. The full range of tones can be found from broad pale washes to concentrated dark areas of color. In each example, the paper remains the sole source of illumination and the contrasting dark tones are a composite build-up of several layers.

Below: Dappled Sunlight, Bridge at Arran, *Maurice Read. A light pencil sketch divides this painting into separate areas — for example, trees, bridge, and sky. Each area has its own independent underpainting, a pale version of the final local color. The picture was then built up with a series of small washes, the most complex part being the water ripples, which incorporate colors from the rest of the picture.*

All the leafy areas had a pale green or yellow underpainting that was overlaid with various darker mixtures of green, yellow ochre, and brown.

A pale wash was applied under the trees. The tree trunks were then carefully reserved out of the surrounding green washes so that they stand out from the foliage.

The bridge's reflection and the sky are incorporated in the river's underpainting as a variegated wash. The reflections of the trees were laid on top to suggest ripples.

The initial underpainting can be seen as a pale Naples yellow, just showing through the darker wash that overlays it.

Below: Lola on the Bridge, *Mark Topham. In this painting, the traditional process of building from light to dark is fully exploited. In the sunlit areas, the yellow underpainting is left as the final color. The darkest areas, particularly in the foreground, are built up with four glazes of different colors, creating optical mixing of yellows, reds, and blues for depth.*

The overhanging branches are a buildup of four loosely applied washes, with a little scumbling. Each layer allows plenty of underpainting to show through.

Pale blue body color was used to pick out the few light blue branches over the dark background.

The yellow underpainting remains largely uncovered here, except for a few odd leaves. It appears fresh and bright and in sharp contrast to the surrounding blues.

Several glazes were applied in the foreground. Masking fluid was applied after each wash to reserve fallen leaves and rocks. Dry-brush techniques were used to build up texture.

How do I handle highlights?

Highlights are the small accents of light that sparkle in a painting, accentuating form and "lifting" the painting off the board. In opaque painting, you would apply them as the finishing touches; in watercolor work, the purest and most luminous highlight is created by leaving areas of the paper unpainted. As a consequence, you need to consider the highlights before you start.

Reserving hard-edged highlights

Hard-edged highlights are sharp and well suited to this wet nocturnal scene. Decide at the outset where the highlights will be and if they will be reserved out of white paper, or yellow or red areas. Then draw them in.

The quickest method is to reserve highlights by painting around but not over the points you wish to highlight, as if you were leaving small chinks of light. This method needs careful brushwork, and you will need to mark the position of highlights lightly in pencil before you begin painting — with large washes, in particular, it's all too easy to obliterate the highlights.

To achieve the hard-edged highlights, paint around them on to a dry surface. A reserved highlight will have a hard edge unless you paint it on to a damp surface, but you can soften it by redamping and touching gently with a cotton swab.

Not all highlights in nature are the pure white of the paper. In a painting where all the tones are dark, pure white could be over-emphatic. If you want to give your highlights a slightly warm or cool bias (depending on the color of the light source), apply an initial pale wash before reserving the highlight. Although faint, it's surprising the difference that this wash can make.

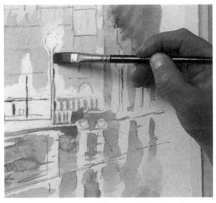

1 Begin with a pencil drawing that clearly shows the position of all light sources and reflections. Use burnt umber and a 0.4 in. (1 cm) flat brush to paint a wash all over the painting, omitting highlights or parts that will be yellow. This clearly establishes areas of light and dark.

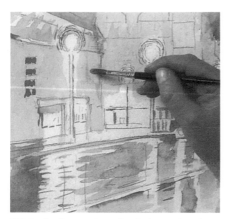

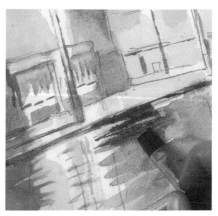

2 Paint further washes of cadmium red and cadmium yellow deep. Extend yellow into the lit-up central area, leaving only white highlights. Paint thin, dry strokes of red and yellow around street lamps. Use red for bricks on the corner of the building on the right.

3 Paint ultramarine into the darker outlying areas and between the bright reflections on the road. This contrasting cool color will "light up" the highlights.

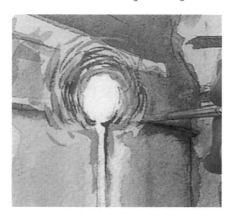

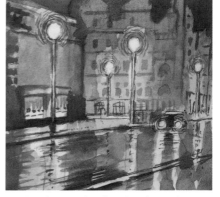

4 Using a finer brush, build up further yellow and red strokes around the streetlights. Work small touches of concentrated yellow around the lit-up area, particularly the street surface, to reflect the light source above.

5 Using the same brush, paint ultramarine around the car headlights. Fill in the car body. Add dark touches with ultramarine and burnt umber as needed. Paint a wash of burnt umber with ultramarine to subdue parts of buildings, highlighting lamps and reflections.

How are soft-edge highlights created?

Cotton swabs, kitchen paper, and natural sponges can all be used to soften the edge of a highlight when wet. A damp cotton swab can also be used to soften the dry edge of a highlight.

ARTIST'S TIP

Using a hard eraser is a good way of creating soft highlights. The process is very gradual and requires repeated strokes to produce results. The darker the ground color, the greater the contrast you can achieve. To keep straight edges or confined areas, use a template.

1 Draw the jug, vase, and flowers, indicating the highlights. Paint the jug in Winsor emerald, lemon yellow, and chrome yellow, working around the reserved highlights, which will initially be hard-edged. Gently rub the highlights with a fine natural sponge, softening the edges and lifting off excess paint.

2 Lay a second wash of Winsor emerald on the jug and repeat the process. When you come to do the highlight for the vase, you can soften the highlight with a piece of rolled kitchen paper. This is more absorbent, so be careful not to lift off more paint than intended.

3 Complete the painting by adding the detail to the flowers and foliage, and a suggestion of background and shadows.

Are there alternative methods for creating highlights?

If you accidentally paint over those tiny highlights, all is not lost. Dry paint can be removed, and sometimes this is the best solution, so as not to interrupt the flow of brushwork. Depending on your method, you can either produce sharp, speckled highlights or soft-edged ones.

To get back to the original white ground, you can scratch, scrape, rub, or scrub the paper. Scratch out a fine line with a scalpel point; as you catch the high points on the paper surface, you will create a speckled line. For a soft highlight, rub a hard eraser on a dry surface, or scrub with a damp bristle brush and dab with a tissue.

If you use a thin template with this technique, you will produce a hard edge to your highlights. For gentle highlights, a dampended cotton swab, sponge, or sable brush can be rubbed on to a dry or damp surface to lift off some of the paint. All these techniques need sensitive application to avoid too much friction, which will damage the paper.

The steps below use two methods to create highlights: initially the white duck is reserved by painting around it, creating a hard-edged highlight which exploits the white paper; then, the softer ripple highlights are made using a hard eraser to remove dry paint.

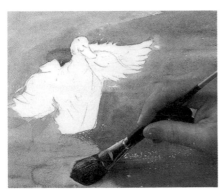

1 With a large squirrel mop brush, paint washes of cobalt blue, ultramarine, and olive green, omitting the duck. Paint a second wash of ultramarine over the right and foreground areas to darken them. Leave to dry.

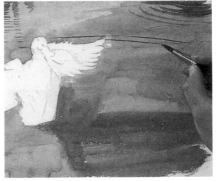

2 With the underpainting done, mix olive green and cobalt blue and paint the reflections of the bank and the ripples on the water.

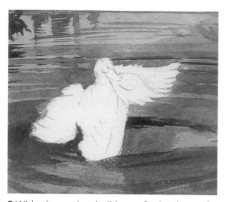

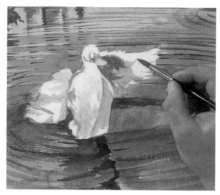

3 With ultramarine, build up a further layer of blue in broad, curved strokes to show the movement of the water surface. These ripples support and amplify the effect of the smaller green ripples, giving the water its shape and suggesting the duck's movements.

4 Paint the reeds on the right in burnt umber and Payne's grey, knifing out the color a little on top. Paint the shadows on the duck in ultramarine and olive green, and use yellow ochre and burnt sienna for the beak. Paint the darker ripples in indigo.

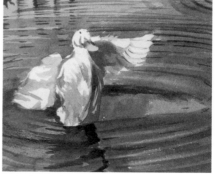

5 Make sure that the paint is dry; then, with a hard eraser, rub repeatedly but not too hard in long curved strokes to remove some of the blue between the darker strips. These soft highlights represent the crests of the ripples.

6 The finished water surface is an accumulation of many different effects, including broad washes, hard lines, dry-brush, and soft, erased highlights. These effects all work in unison, with none dominating the others.

How is a razor used to create highlights?

A razor blade or a scalpel can be used to scratch off the pigment, slightly raising the paper surface as you work, to create effective highlights.

Check that the painting is finished before using a razor to create highlights as, once the surface has been scratched, subsequent over-painting will be blotchy.

1 Begin by applying a graduated wash in light red over the whole picture area. While still wet, drop Payne's grey and Antwerp blue in the upper and lower thirds of the picture, avoiding the horizon area. Leave to dry, then paint the land with Payne's grey.

2 Apply another, darker wash on the distant water. Leave to dry. Then, using a razor blade, gently scratch out long horizontal lines, allowing the blade to skip over the rough paper surface to form white beads.

3 The soft, blended background and dark horizon contrast with and enhance the calm, sparkling water, producing an ethereal effect. Because of the speed of watercolor work, you should be able to complete this evocative painting in under an hour.

Can I use body color to create highlights?

Using body color allows you to put highlights in when the painting is almost complete, when it's easier to judge where they should be and how bright they need to be in comparison to the other hues (see *Glossary*).

Body color is the most effective way of creating tiny highlights. With masking fluid, the results are not known until you rub it off, but body color is more controllable and gives immediate results.

Using body color will allow you greater freedom to paint highlights in with a variety of brush strokes. Dry-brushed highlights are also effective: mix Chinese white into a thick paste and add a hint of yellow to make it glow.

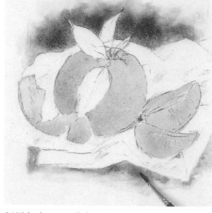

1 With the pencil drawing completed, paint yellow gamboge over the orange, the peel, and segments. Paint the shadow under the napkin with ultramarine and violet.

2 While the orange is still damp, paint in the shaded areas with cadmium red deep mixed with the yellow. Mix chrome yellow with Prussian blue and paint the leaves. Add a second wash to the leaves when the first is dry.

3 With a stronger mix of cadmium red deep and a little yellow gamboge, build up peel texture with small washes and flecks of paint, made with a No. 0 brush. Use the same color on segments. Use Payne's grey for shadows.

ARTIST'S TIP

Some artists use Chinese white as a final detail at the end of the painting process. A good example of this would be when painting boats in a harbor scene, the white can be used to paint all the highlights on the sea with far more ease than reserving them. Chinese white can also be used in portraiture, as the reflection in subject's eye. Bear it in mind when making preliminary color sketches for paintings, too.

4 Use concentrated Chinese white and a No. 0 brush to paint dotted highlights on the peel. Apply a greater concentration of dots in the center of the highlight area, then thin them, using smaller touches, as you move outward.

5 The method of applying the dots helps to describe the spherical shape. The specks of white paint are almost entirely confined to one area, which has a greater impact.

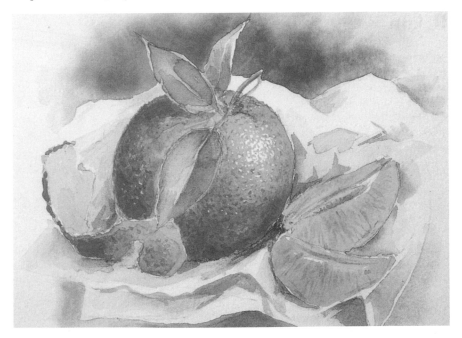

Can scrubbing be used to create highlights?

Scrubbing is a method of removing the pigment when it is dry, using a bristle brush, to reveal the white paper underneath. This technique creates loose, textured highlights, ideal for representing fabric. Use a No. 1 or No. 2 bristle brush with short hairs, as they will give you more precise control.

1 Apply a background wash of cadmium yellow and magenta. Paint cloth folds and floor in ultramarine. Overpaint cloth with cadmium red and magenta.

2 When the paint is dry, scrub the highlight areas with a bristle brush to soften the pigment. Then dab off the softened pigment using a clean tissue.

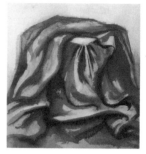

3 Paint a final wash of magenta around the highlights to crisp up the edges and deepen the shaded areas. Paint the floor with an emerald green wash.

How does masking fluid work?

Masking fluid is a liquid rubber solution which can be painted on to an area to reserve it for highlights. When it is dry, it rubs away to reveal the unpainted white paper underneath.

With masking fluid, you can paint highlights in fine detail and with infinite variety. If there are too many fiddly highlights in an area that you want to treat with broad, flowing brushstrokes, masking fluid is the answer: it can free you to paint unhindered, the only drawback being that the highlights may appear mechanical, with hard edges. You can solve this problem by wetting and stroking over the highlights afterward with a bristle brush.

To reserve tinted highlights, paint over a dry wash with masking fluid. Once painted on, allow it to dry before resuming painting, and let the painting dry before rubbing the fluid off.

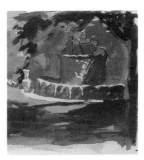

1 Lay an ultramarine wash on wall and a cadmium red wash over highlight areas. When dry, apply masking fluid.

2 Paint the rest of the scene. When dry, rub off the masking fluid to expose the pale pink highlights.

3 The reserved, tinted highlights, made with the original cadmium red wash, seem to glow in the sunlight.

How do masking techniques allow me to paint fluidly?

You will need the freedom to paint loosely behind the complicated shapes of the chairs and plant highlights, while retaining the freshness of the paper.

Masking the areas to be highlighted allows you to paint in the areas in the background fluidly, without worrying about overpainting your reserved areas.

1 Cover chairs and highlighted leaves with masking fluid. Paint background and shadows in muted tones.

2 When the paint is dry, rub off the masking fluid and continue painting on to the now-exposed white paper.

3 Paint sap green on to the exposed leaves, define chairs in pale strips of cerulean blue and cadmium red.

What is wet-in-wet painting?

Wet-in-wet painting is exactly what its name implies — applying each new color without waiting for earlier ones to dry so that they run together with no hard edges. This is a technique that is only partially controllable, but is a very enjoyable and challenging one.

Wet-in-wet painting is perfectly suited to the properties of watercolor, or any water-based paints can be used, providing no opaque pigment is added.

The paper must first be well dampened and must not be allowed to dry completely at any time. This means, firstly, that you must stretch the paper (see *How is paper stretched?*) unless it is a really heavy one of at least 200 lbs (90 kg). Secondly, it means that you must work fast.

Paradoxically, when you keep all the colors wet, they will not actually mix, although they will bleed into one another. Placing a loaded brush of wet paint on top of a wet wash of a different color is a little like dropping a pebble into water; the weight of the water in the new brush stroke causes the first color to draw away.

The danger with painting a whole picture wet-in-wet is that it may look altogether too formless and undefined. The technique is most effective when it is offset by edges and linear definition; so when you feel that you have gone as far as you can, let the painting dry, take a long, hard look at it, and decide where you might need to sharpen it up with some well-planned brushwork.

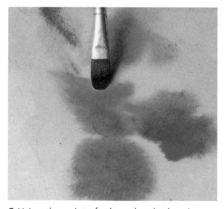

1 Make a preliminary outline drawing on the paper, then dampen it thoroughly with a sponge. Here the water is slightly colored to provide a background tint.

2 Using the point of a large brush, drop in areas of color, allowing them to spread and merge together.

3 Let the paper dry a little before touching in the darker colors, so that they have crisper edges when they dry.

4 As highlights cannot be reserved when working in this way, opaque white can be used to add in highlights.

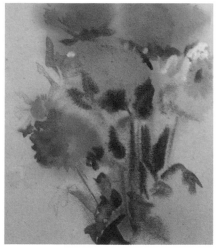

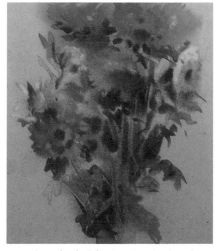

5 Continue to build up the color using slightly thickened paint.

6 Touches of soft definition give depth and form to the leaves and flower heads.

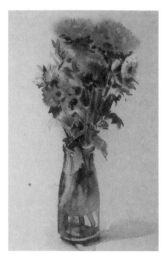

7 Allow the painting to dry before completing the vase, so that the vase wash will not spread. Apply a loose, wet wash of darker paint to the base of the vase and then tilt the board so that the paint runs in the right direction. This is the best way of controlling wet paint and is surprisingly accurate.

8 Wet-in-wet is such an enjoyable technique that sometimes the artist does not know when to stop and the painting becomes woolly. Here, although the general effect is soft, there is enough definition and tonal contrast to pull the composition together.

Are there any tips for successful wet-in-wet painting?

Depending on the wetness of the initial wash and the type of paper used, watercolor can take anything up to 15 minutes to dry thoroughly, so the technique does require a little patience. If detail is applied too soon, the colors turn muddy and the definition is lost.

The wet-in-wet technique is especially suited to the representation of natural forms. In floral art, wet-in-wet is effective when combined with wet-on-dry passages. The wet-in-wet washes capture the delicacy of leaves and petals in the initial stages, then further washes applied over the dried underlayer add form and definition.

In landscapes, the illusion of rippling water can be created using both wet-on-dry and wet-in-wet techniques. The hard and soft edges formed by overlapping wet and dry washes give the effect of gently moving water.

Are there variations of wet-in-wet painting?

A wet-in-wet wash makes the ideal background for working over, and the softness of the result perfectly describes many natural phenomena. When painting layers of atmosphere in a landscape, you need to give vague definition to distant objects. You can also use this technique to blur less important parts of a composition so that they have less prominence.

1 With a 2B pencil, define three main areas: ground, smoke, and trees, adding a little detail. Brush a pale wash of cobalt blue and burnt umber over the tree area. Before this is dry, loosely paint patches of ultramarine into the smoke area, allowing it to blend with the wash on the trees.

2 Brush a pale strip of sap green and burnt sienna on the ground and allow them to fuse together. When dry, mix cerulean blue and new gamboge. Paint this on the leaves and burnt umber on the trunks, allowing them to blend together leaving no hard edge between trunks and leaves.

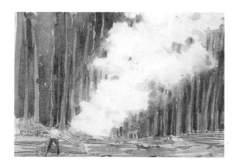

3 Blend the trunks and smoke on the bottom right in the same way. When all the wet-in-wet blending is completed, finish off by painting the foreground detail and figures with a fine pointed No. 4 brush.

4

SPECIAL
TECHNIQUES

What are backruns and how are they achieved?

Backruns can occur when painting wet-in-wet. As you drop clear water or paint into a damp wash, it doesn't blend in the usual manner but displaces the original color, spreading out and forming a hard-edged irregular puddle. This could ruin a perfect wash or be a blessing in disguise.

You may sometimes want to create a backrun deliberately to enhance your painting. In this case, lay the initial wash and wait until it's just damp, when the sheen leaves the surface. Then drop in either clear water or fresh paint in large droplets. The surface dampness will act as a vehicle to spread the paint, but it won't be wet enough to merge both layers. After expanding slightly, the paint will dry, leaving an irregular, hard edge with a concentration of pigment near the outline. If you want to avoid backruns, don't be tempted to add any more paint while the wash is still drying.

Backruns are a particularly useful watercolor technique. Because they give the impression of having formed naturally, they can complement a roughly weathered surface or natural phenomena such as clouds. Use more fluid if you want to create flowing, unrestrained backruns.

Once understood, backruns can be controlled by careful timing and by accurately judging the quantity of liquid dropped in, which influences the size to which they grow. Granular pigments respond better than staining colors.

1 Paint walls with burnt umber, burnt sienna, yellow ochre, and sap green. Leave each layer to dry for two minutes. Charge the brush with water or more paint, and touch the spot where you want a backrun with the tip of a brush.

2 A number of small backruns can be seen on the walls. These break up the flat washes to give them character and interest. Backruns appear more dramatic on dark washes because larger amounts of pigment are displaced.

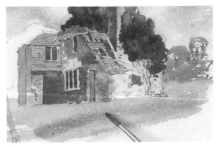

3 Paint the trees with sap green, olive green, burnt umber, and ultramarine. Use burnt sienna and cadmium red light for the chimney. Create backruns on the trees and the chimney.

4 Loosely brush the sky with a pale wash of ultramarine and apply a wash of raw sienna over the foreground. Paint the trees with sap green mixed with the little raw sienna.

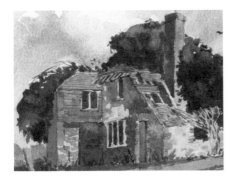

5 The backruns are used here constructively and judiciously to convey variations in color and texture. They are not allowed to overwhelm the overall composition, which is a risk if too much liquid is used.

Unrestrained backruns

1 Unrestrained backruns are ideal for creating smoke. Apply violet, Venetian red, and black wash to left. Use Naples yellow on towers and ultramarine for sky behind.

2 Overlay additional washes of black and ultramarine. To create large flowing backruns, make sure the brush contains plenty of fluid.

3 Finish the towers with black, burnt sienna. Large backruns can be seen in the blue and black smoke, adding to the ominous atmosphere.

What is blending and how is it achieved?

Blending is a delicate procedure which is used to create soft tonal changes on a small scale. It is used to paint the gradual change of light around a curved object or to conjoin two colors, both of which take a substantial amount of control. Blending is frequently used for detail in still life, and offers the perfect technique for painting skin tones in portraits.

When blending colors, speed is important. You work into wet paint using little water so that the paint will dry fast, which risks an edge forming.

To blend one color from dark to light, you have to develop a fairly fast action. Start by laying the darkest tone, rinsing the brush with water, draining the excess water into a tissue, then returning the damp brush to the paper to stroke the still-wet paint, dispersing and blending it.

To blend two colors, lay them alongside each other and, with repeated strokes, merge them together. In this case, you won't need to rinse the brush until you have finished blending.

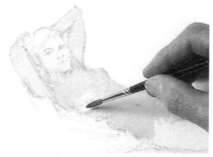

1 Draw the model's contours. Mix a little cadmium red light with new gamboge, and lay a soft wash over the figure, omitting right breast. Clean brush, shake out excess water, and soften the edge formed around the breast.

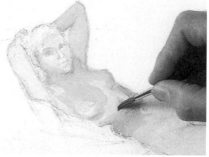

2 Using a stronger mix of the same colors, continue modeling the face and torso, carefully blending away hard edges, to create rounded form and gentle curves. Always use a little paint to keep full control.

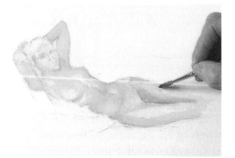

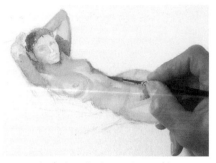

3 Follow the same procedure down the legs. Apply paint down either side of each leg, then soften the edges down the inside, leaving a lighter tone down the middle. This will convey the rounded form of the leg.

4 Paint the hair with ultramarine and burnt umber. Add more concentrated skin tones to accentuate the form. Use deeper tones in the recesses. Continue along the arms, the top edge of the body, and around the abdomen.

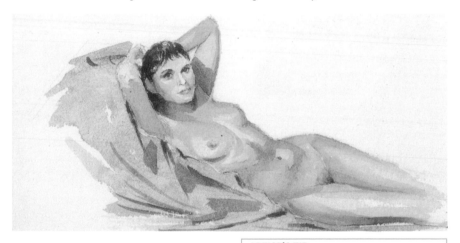

5 Paint the fabric with cerulean blue mixed with cadmium red light. Use ultramarine for the creases. Add in all the remaining details to face and body. Use cadmium red light for the lips, and ultramarine with cadmium red light for the eyes and brows.

ARTIST'S TIP

To convey the roundness of a piece of fruit or a face, use the paint fairly dry, applying it in smaller strokes rather than broad washes. If unwanted hard edges form, they can be softened by painting along them using a small sponge or cotton swab, dipped in a little water.

How is fusion of colors achieved?

To fuse two colors at the point at which they meet, use a clean, wet brush to gently stroke the two colors together, avoiding any hard line forming when they dry. This is especially useful for soft, rounded shapes, such as the urns below.

1 Paint the background with flat washes, keeping within the pencil guidelines. To prevent two colors bleeding into one another while one is drying, move around the picture. Use mixtures of yellow ochre, Hooker's green, alizarin crimson, and cerulean blue. Add further layers of color to suggest detail.

2 Paint the urn in the foreground by laying yellow ochre at the top with a little cerulean blue. Then paint burnt sienna at the bottom. Carefully blend the colors together by stroking sideways with a clean, wet brush where they meet. Repeat for the smaller urn.

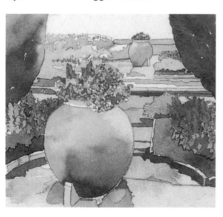

3 In the finished picture, everything serves to emphasize the large urn. The trees and flowers frame and focus the eye on the urn. The gently curving surface of the urn is prominent and creates a contrast with the muted flat, grey washes behind.

What is the dry-brush technique?

The dry-brush technique, which may at first appear a haphazard method, can, when fully mastered, become an expressive addition to your watercolor repertoire. The basic principle is that insufficient or thick, sticky paint, combined with a fast arm action, will cause the brushstroke to disintegrate gradually. Dragging the side of the brush helps. If there is excess fluid, you can squeeze it out of the brush with your fingers. To vary the effect, you can splay the brush hairs out with your fingers while painting. Reducing the downward pressure on the brush during the stroke will produce a more fragmented effect.

Most watercolor techniques take advantage of the fluidity of the medium; this technique exploits the medium's potential dryness. Observe how a sweeping brush stroke unloads its paint and gradually breaks into a stream of fragmented color. The rough paper surface plays an important part in this process as the paint becomes too dry to fill the valleys.

Dry brush as texture

Dry brush is used here specifically to portray a harsh, rugged environment. It has a dual function as texture for the snow-clad mountain and also to impart the sensation of movement as cold wind lashes the grass. The latter effect is achieved with broken, diagonal strokes for the grass.

1 To convey the foreboding sky, wet the sky area with a large squirrel-hair brush. Using sweeping, horizontal strokes, drop in strong solutions of first Payne's grey, then black. Allow them to bleed together and spread.

2 When the sky has dried, barely dampen the brush with a mix of violet and black. With light, downward strokes, and holding the brush at an angle, paint the side of the mountain. Skim the paper surface so that the brushstrokes break up.

3 Paint a band of Payne's grey above the mountain and the middle-distance hills. Lay a pale black wash over the foreground and leave to dry. With a just-damp brush, paint diagonal strokes in burnt sienna and Vandyke brown for the grass. Keep strokes at the same angle.

4 Paint over the grass with black dry-brush strokes. Use wetter, curved strokes to suggest the shape of the snow mounds on the ground.

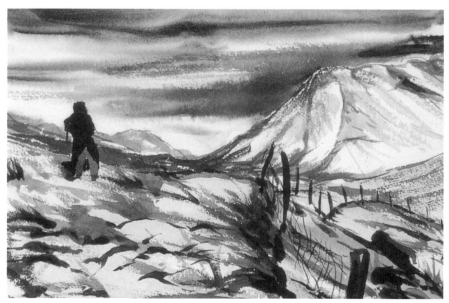

5 Add the main points of interest — the fence with its curved perspective, and the figure, painted in Vandyke brown, black, and grey.

Can I paint highlights with a dry brush?

The dry-brush technique is highly effective for creating highlights because the paint strokes allow the paper to show through as the stroke disintegrates.

You can see here how the dry-brush technique is perfect for representing the sparkling water surface as the low sun reflects over calm sea and wet sand.

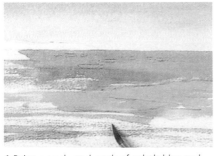

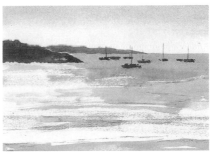

1 Paint a graduated wash of cobalt blue and lemon yellow in the sky. Mix violet with cobalt blue for the sea, and Vandyke brown with violet for the foreground. Paint wet brushstrokes on the right side of the picture and dry brush on the left half.

2 Mix a neutral tint with ultramarine for the shoreline and yachts.

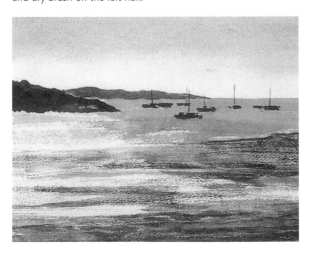

3 Mix a fairly thick solution of neutral tint and, using the side of a No. 10 brush, skim long, horizontal strokes over the beach area to build up the rich texture of the foreground.

How do I use masking fluid?

Masking fluid is ideally suited to the watercolor artist's work. It is a rubber solution which, when applied quickly, dries in contact with air, sealing the paper completely. When it is dry, you can easily rub it off with your finger or with a ball of dried masking fluid.

You often have to paint around awkward shapes, creating patchy brushmarks as you follow the difficult edges. If you mask the shapes first, you can paint over them, freeing the brush to paint a smooth background.

Take care not to leave masking fluid on for more than a day, or it could tear the paper when you rub it off. To clean the brush during use, stir it in concentrated washing-up liquid, then rinse in warm water. To remove more stubborn rubber, soak temporarily in denatured alcohol (white spirit), then comb out with a clean toothbrush.

It is tempting to use an old paintbrush for painting the masking fluid on, as the fluid clogs brushes quickly, and they need stern cleaning methods. However, it is best to use a good, fine brush with this fiddly technique, otherwise the spots of sunlight will appear as awkward shapes.

1 Make a preliminary pencil sketch that notes the position of any highlights. Apply a pale wash of cadmium red all over the areas on which highlights are planned. Dry this thoroughly — with a hair dryer if necessary. Use a soft No. 2 brush to reserve highlights with neat masking fluid. Leave to dry.

2 Continue to build up the picture with progressively darker washes of sap green, ultramarine, burnt sienna, Payne's grey, and violet. Notice how the dried masking fluid displaces the paint and shows up as yellow patches of sunlight.

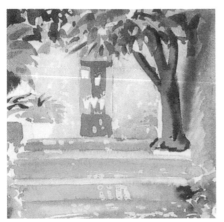

3 Paint the tree trunk with burnt umber and violet. Then add indigo along the dark side of the trunk and to the darkest leaves.

4 When the paint is dry, rub off the masking fluid. Using a clean finger, first skim over the large areas, breaking up the surface. Then rub away a little at a time, checking for any missed patches and taking care not to tear the paper.

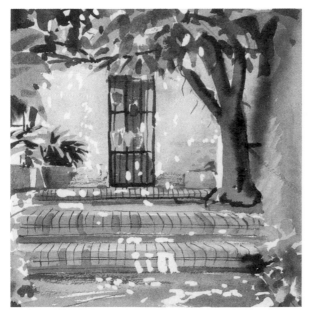

5 After you have rubbed off all the masking fluid, brush off the bits with a large cloth or kitchen paper. The initial red wash, although pale, makes a significant, warm difference to the highlights that are now exposed.

How do I use masking tape?

With its qualities of low adhesion and ease of cutting, masking tape is tailor-made for the job of masking where a straight edge is required. You can lay down whole strips to mask the edge of large buildings, or parallel overlapping strips to cover large areas. Alternatively, you can cut out shapes from the tape to make stencils.

The thicker the paint you are using, the less likely it is to bleed under the tape. Brush it on in one clean stroke, and leave to dry before stripping off the tape. To make an irregular edge, secure a torn paper edge in position with tape. Then paint over and away from the torn edge so that paint is not forced underneath the tape.

To mask a rectangle accurately, or to enable you to paint up against a long straight edge, it's easiest to use masking tape. For an irregular shape, such as the tree line on the horizon, you can use the torn edge of a sheet of paper.

1 Draw heavy outlines over the object you wish to mask. Lay the masking tape in strips over it to cover the complete shape. With a scalpel, cut around the shape. Be careful not to cut the paper.

2 Peel away the superfluous tape. For small enclosed areas, carefully lift up a corner with the scalpel, then peel off. Press down the remaining tape in case it has lifted in the process.

3 Use Hooker's green dark to paint leaves. Use cerulean blue on window, light red and burnt umber for wall and pots, and Payne's grey for paving. Use Winsor violet for the shadow under fork.

4 Finish the foliage, adding a little Prussian blue. When all the paint is completely dry, peel off the mask. Do this slowly to avoid tearing.

5 If there are any pencil lines visible inside the fork, rub these off. The way the paint has been applied has helped to prevent any seeping under the tape, so you have a perfectly clean edge.

6 Use a No. 1 brush to complete the fork detail in cerulean blue and burnt umber. This will prevent it from looking like a cut-out. The shadow behind the fork is important because it links it with the background.

ARTIST'S TIPS

• Most masking tapes are semi-transparent so, when you lay them over a drawing, you can see through them sufficiently to cut out the shape you wish to mask. Take care when cutting not to score into the paper, otherwise it may tear when you pull off the mask.

• One advantage tape has over masking fluid is that it's easier to get accurate, straight lines with freehand cutting or, if necessary, with a ruler.

How is a torn paper mask created?

Blotting paper makes an ideal freehand mask. It tears with a serrated edge and, when painted over, prevents water seeping underneath by absorbing it.

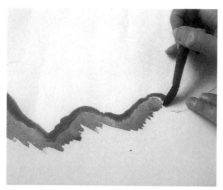

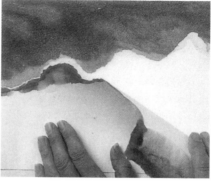

1 Tear the blotting paper to shape, lay it in position, and brush paint on to a dry picture surface across and away from the torn edge so you don't force paint underneath.

2 When you have established the outline of the mountains, fill in the sky with Payne's grey and Antwerp blue. Lift the mask carefully to avoid smudging the wet paint.

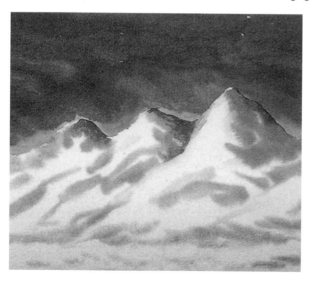

3 Dampen the surface of the mountains and apply strokes of Payne's grey. Add some darker grey to the right side of the peaks. The end result is simple but effective, giving to the mountains a rocky, three-dimensional appearance.

How is lifting out explained?

Removing paint from the paper is not only a correction method, it is an integral part of watercolor painting technique. It can be used to great effect to soften edges, diffuse and modify color, and create those highlights that cannot be reserved. Lifting out can also be useful for "negative painting" — for example, lifting an object such as a cloud out of the painted surface is more effective than trying to paint around it. And, for correction purposes, it is easy to lay down excessive color or too much water, in which case you will need to soak up the excess.

A "thirsty" brush, sponge, cotton swabs, blotting paper, cloth, and facial tissues all make excellent lifting-out tools. On a dry surface, scrub with a bristle brush, then dab with tissue.

Is there an example of the lifting out techniques?

In order to lift off paint effectively, this scene has to be overpainted using excessive paint. This will allow plenty of scope to get back to white paper, and create lots of contrast. Take care not to overdo the paint application because this can have a deadening effect. As this is a hard technique to master, practice first.

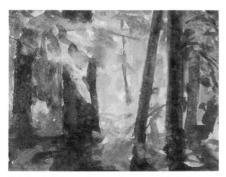

1 Paint bright background areas with Indian yellow, trunks in Vandyke brown, and leaves in olive green, terre verte, and cobalt blue. The foreground shadows and yellow background give the impression of backlit trees.

2 Use a moist, short-hair bristle brush and a thin, metal template to lift out the paint and reveal light rays with clean sharp edges. Work with little pressure, so the paper surface isn't roughened. Mop up the residue with tissue.

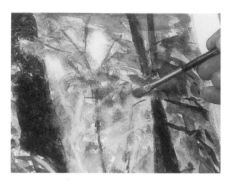

3 To remove large areas without sharp edges, work over the paper freehand with the brush. The brush should be slightly wetter than in the previous step in order to dampen the surface and dislodge more of the pigment.

4 While the surface is still damp, dab a tight wad of tissue over the surface, picking up the paint residue without leaving any unwanted texture. Do this gently: a wet paper surface is more vulnerable to damage.

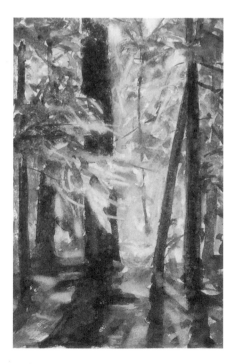

5 The finished picture is light and airy, with rays of sunshine breaking through the trees. The sharp contrast between the darkest trunk and the light area in the center of the picture makes these rays appear intensely bright.

How is lifting out on a wet surface achieved?

Lifting out of a wet surface requires quick reactions, so have the tools ready.

To soak up paint from a wet surface, dab with a tissue before the paint has had time to soak in. By crumpling the tissue, you create interesting textures. A thirsty brush (one that's clean and dry enough to soak up water) will lift lines out of a damp surface. Blotting paper is as effective as tissue, and creates textures.

1 Lay a graduated wash of Antwerp blue, making it darker at the top and paler at the bottom. Holding a crumpled tissue, press down firmly in the cloud area to dab off the paint. This will expose almost perfectly white paper.

2 When this has dried, add a little Payne's grey into the white area. This time coil the tissue to a point, and lift off the color around the edges of the grey. This exposes the silver lining of the backlit cloud.

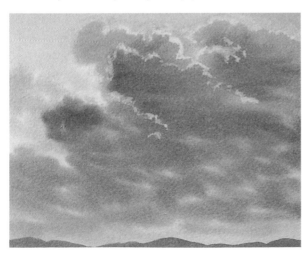

3 Paint the distant hills in diluted Payne's grey, then add a strip of more concentrated color for the foreground.

How is blotting paper used for lifting out?

The aim is to partially lift off the paint, leaving a texture on the ground.

1 Paint the woods in Indian yellow, olive green, cadmium red, and Vandyke brown. Then lay a wash of Winsor violet and Vandyke brown on the ground.

2 Paint the ground with a more concentrated color. Lay the blotting paper over it and stroke it gently with your hand, to remove some of the paint. Peel off the blotting paper.

3 Spray the trees with an atomizer for an effect that corresponds nicely with the texture on the ground. If necessary, repeat the blotting paper technique on the ground to build up more texture, or simply paint over it with a few well-placed brushstrokes.

How are textures achieved with texture paste?

You can manipulate textured paste with a palette knife or toothbrush to form a wide variety of surface textures. It can be bought either ready-made in jars or you can make it yourself by adding fine sand or Polyfilla to acrylic gel or white glue. Once dried, like acrylic paint, it will not dissolve when painted over.

1 Paint the sky with a broad wash of ultramarine and violet. Use burnt sienna to paint the foreground and violet and Venetian red for the distant land.

2 With a painting knife, smear the textured paste on the hill. Add a layer to the right of each windmill. Move it over the surface to resemble sand and rock. Allow to dry.

3 Brush fairly thick burnt sienna over the hillside, skimming over the textured parts to allow the gritty texture to show through.

4 From left to right, paint horizontal strips of Naples yellow, violet, and ultramarine on the walls of the windmills.

5 Work a thicker coat of sepia and ultramarine over the hillside for the shaded areas. Use Payne's grey, burnt sienna, and ultramarine on the road. Skim Naples yellow body color over the parts of the hillside to resemble low sunlight. Paint in the windmill sails and windows with a rigger. The textured paste contributes to this portrayal of the rugged landscape of La Mancha in central Spain.

What are "salt" effects?

Salt is a water-soluble crystal that gradually dissolves and displaces the paint that immediately surrounds it, creating intricate, flowery patterns.

This is a slow process, so leave plenty of time. It takes up to 20 minutes to dry thoroughly, after which you can gently rub it off with your fingers.

1 Apply washes. Sprinkle sea salt into wet paint. Use more water in washes than usual to give salt longer to act.

2 Paint sky yellow ochre, sprinkle on salt. Use burnt umber with Venetian red and black to house, then add salt.

3 As you complete each area of the row of houses on the left, sprinkle a few grains of salt into the wet paint.

4 Leave to dry for 20 minutes, then use your fingers to rub the salt off.

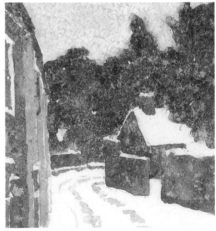

5 The result is a mysterious effect where the texture resembles snow crystals, giving a distinctly wintry feeling. Little detail is necessary, as it would detract from the effect.

How is plastic wrap used to create textures?

When spread over a wet wash, plastic wrap creates a roughly textured surface, ideal for representing rough stones, bark, or roads. Try out this technique on a scrap piece of the same paper you will use in the painting. Your first attempt does carry a high risk of failure, but remember that you can always turn the paper over and try the technique again until you are happy.

1 Lay a wash of burnt umber and raw sienna on the road. Lay a piece of plastic wrap over wash. Brush over it with the side of your hand. Leave in place for a few minutes.

2 Peel off the plastic wrap before the paint is completely dry. Hasten the drying with a hair dryer. (Don't put the plastic wrap back on.)

3 Fill in the rest of the picture with broad washes. Use ultramarine and violet in the sky, and burnt sienna and sap green on the ground areas. Leave to dry.

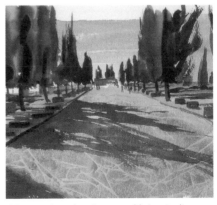

4 Paint the trees with a wash of burnt umber, brushing in vertical streaks of black while wet. Use burnt umber for blocks by road, burnt sienna in trees, and violet for building at end.

5 To complete the picture and bring it alive, paint the dynamic tree shadows with a mix of magenta and ultramarine. Glaze these over the road texture to unite the composition.

How is texture achieved using sandpaper?

Sandpaper can be rubbed over selected areas of dry paint to lift it off, creating rough, granulated highlights which are ideal for representing textured surfaces.

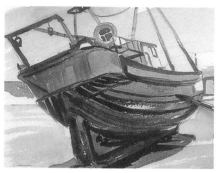

1 Paint sky with cobalt blue washes. Dry brush sand in Naples yellow and burnt sienna. Paint boat with burnt sienna, Indian red, cobalt blue, and raw umber. Overpaint black bands on hull. Build up boat's shadow in Payne's grey glazes.

2 Build up dark shadow tones on hull with dry brush. Fold a small piece of medium grade sandpaper. Rub it along boat's hull, mostly on the side, and a little on the back and lower part. Be careful not to rub off too much paint.

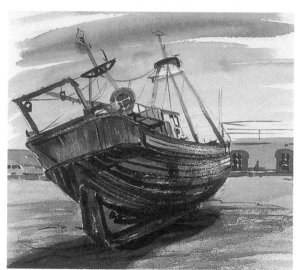

3 The combined textures of dry brush on the beach, and sanded and dry-brushed areas on the boat work effectively together, to capture the essence of this rugged, textured subject.

What is imprinting?

Imprinting is a technique where paint is transferred from a textured surface to the paper. A huge range of materials can be used: fabrics; foil; natural materials; anything that can carry the paint. Here, the effect of corrugated cardboard is explored, exploiting its ridged texture to represent a stone bridge.

1 Lay an initial wash of cadmium yellow everywhere except areas to be painted blue. Brush burnt umber on to corrugated cardboard, press it repeatedly on to bridge. Repeat on foreground, using sap green on cardboard of a different texture.

2 Apply burnt umber wash over tree trunks. Use the cardboard edges to create branches of tree on left. Mix indigo and cerulean blue, and press above and below the bridge for foliage, using a fresh piece of cardboard. Paint a cerulean blue wash on the distant mountains.

3 Using a fresh piece of torn cardboard for each color, build up the colors around the picture. Complete the picture with cadmium orange applied to the foreground.

ARTIST'S TIP

Since watercolors are applied in thin layers, they cannot be built up to form a surface texture like other paints. Instead, texture can be added using techniques such as those described above, or alternatively, it can be supplied by the grain of the paper. There are many watercolor papers on the market, some of which are so rough they appear to be embossed, especially the handmade varieties. Rough paper can give exciting effects, as the paint settles unevenly, breaking up color and leaving white flecks showing through.

What is stippling?

Stippling involves applying color as a mass of small dots, using a fine brush or pointed instrument, to create a stunning, Impressionistic effect.

Rather than mixing colors on the palette, you apply them side by side so that they mix optically. Different-colored dots, interspersed in varying proportions and viewed from a distance, fuse in an extraordinary way. Use the tip of a fine sable brush to make small dots. The tip of a large decorator's or hog's hair brush with a flat end produces groups of tiny dots. Make the dots by dabbing with a pecking motion, building up a mosaic of flecks. The best paint consistency is creamy: if it is too wet, the dots may merge or dry too faint.

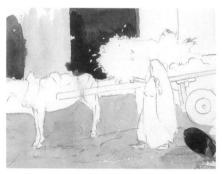

1 Paint background buildings with flat washes of black, cerulean blue, and burnt umber, outlining donkey and cart. Apply a wash of burnt sienna to ground. Use a mop brush that can be drawn to a point or a smaller sable.

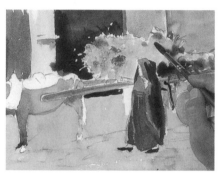

2 Paint donkey and cart in burnt umber. Paint vegetation in sap green with a little black, dropping more concentrated paint into the wet surface later. Paint woman's clothes in indigo, adding concentrated streaks to wet paint.

3 Build up the donkey using black and burnt umber. Use a mix of burnt umber and burnt sienna to paint the shaded ground, including the shadow cast by the donkey. With the decorator's brush, stipple a fairly wet solution on to the ground to represent the texture of sand and earth.

4 Use the decorator's brush to stipple a fairly wet solution of viridian on the vegetation. When dry, follow with a thick, almost dry mix of sap green and black. This second layer will have a finer texture.

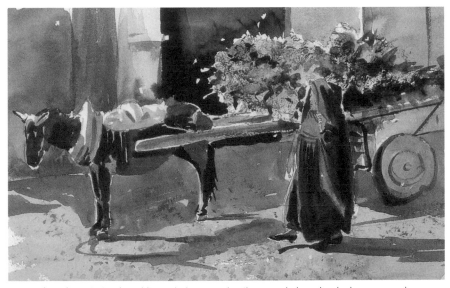

5 Complete the painting by adding a little more detail, as needed, to the donkey, cart, and woman. Add a few brushstrokes in sap green and black to the vegetation to suggest shaded areas.

What is a stipple buildup?

Stipple buildup is the use of layers of colors, stippled on in various shapes and densities of dot, using a variety of brushes, to build up a complete picture.

1 Lay pale washes of Hooker's green and burnt umber. Mix cadmium red with yellow, stipple over damp washes with same brush. Use a drier paint mix and let brush hairs splay.

2 Apply burnt sienna to damp and dry areas, using the same stippling technique. Create flecks of different shapes and sizes by varying the pressure on the brush.

3 Build up stipple with layers of ultramarine, violet cadmium yellow, and Hooker's green. Paint some long strokes of ultramarine to represent tree trunks and their shadows.

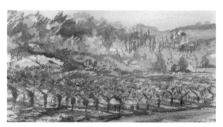

4 Build up the foliage with layers of Hooker's green and cadmium red. Emphasize trunks and suggest branches in sepia. These brushstrokes stop the painting from becoming abstract.

Can a sponge be used to paint with?

The sponge is a versatile supplement to the brush. When dabbed on, it creates a convoluted texture; when stroked or dragged, it elongates the paint texture, in imitation of foliage or grass.

Try a few types of sponge, natural and synthetic, fine and coarse. Sponges hold a lot of paint, which can be applied very wet, or dabbed on with light pressure for a delicate effect.

1 Paint sea with a wash of cerulean blue. For trees, drop in burnt umber, then add olive green, using wetter paint for distant leaves. Paint foreground in wet-on-dry washes.

2 When dry, use a coarse sponge to apply diluted olive green to the distant trees. Drag the sponge a little in different directions to vary the direction of the texture.

3 This close-up shows the effect of flicking the sponge at different angles to represent the spiky foliage of an olive tree.

4 Continue the same technique with the trees on the other side of the path. Vary the effect by rolling the sponge on its side. Use different sides of the sponge for different techniques.

5 Using a brush, paint in details of the scene in ultramarine, Hooker's green dark, burnt sienna, yellow ochre, and black. Take a fine sponge and dab a fine texture of black over the existing paint for the leaves in deep shade.

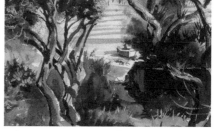

6 The sponge painting technique has been confined to the top foliage. It does not dominate or overwhelm, but has been integrated into the overall composition, adding an exciting realism to the trees.

What is sponge buildup?

Dabbing paint on to paper with a sponge gives an attractive mottled effect, especially if the paint used is fairly thick. Sponge buildup involves working the sponging technique up using varying densities and dilutions of paint, types of sponge, and layers of color, to build a picture, or a part of a picture.

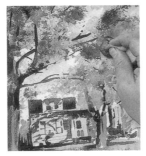

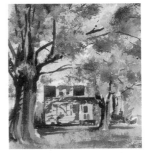

1 Lay variegated washes for trees, house, ground, and sky. When dry, use a fine sponge to dab a thicker consistency of burnt sienna over leaves.

2 While still damp, paint in branches with burnt umber and black. Paint house details in black. Sponge burnt sienna and olive green over ground.

3 Varying the thickness of the sponging gives the painting vitality, while a little supplementary brushwork adds structure.

How is spattering with masking fluid used?

Spattering is an exciting medium with special qualities, especially the ease with which you can produce an impressive effect. A fine spray of paint, or masking fluid over a sandy wash, gives a realistic interpretation of sand and stones, while large splashes impart vivacity in an expressive style. For reverse dots, spray masking fluid on to a dry surface, rub off, then paint. Spattering is best used as a supplement to regular painting.

A toothbrush is the most popular tool for spattering. The amount of control possible depends on how close the paper is. Dot size varies depending on the quantity of paint in the brush. For large, splashed dots, tap a paintbrush on to a finger, about 6 in. (15 cm) from the surface. You can mask surrounding areas by taping on sheets of paper. Water spattered into a wet wash displaces paint in puddles.

1 Lay a pale wash of cadmium red on the forecourt and sap green on the surrounding foliage. With a No. 2 brush, paint masking fluid over the sunlit areas on the forecourt and over the sunny spots on the bushes. Leave to dry.

2 Paint washes of cadmium yellow, sap green, Prussian blue, and black on the bushes. Allow them to mix on the paper surface. Paint indigo on the garage door, leaving a little white paper showing, and ultramarine on the garage walls.

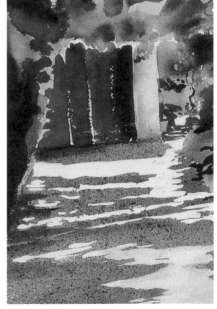

3 Apply washes: violet at the garage end, burnt sienna and Payne's grey in the foreground. Remove masking fluid from the bushes and then paint flowers in cadmium red and yellow.

4 Tape sheets of paper around the sides of the forecourt. Using a toothbrush, spatter on layers of burnt sienna and Payne's grey. Have kitchen paper ready to dab away any overlarge dots or any excessive concentrations of spattered dots.

5 Rub off the masking fluid. Add Payne's grey in the left-hand shadow, to intensify it. The forecourt shadows are hard-edged, conveying the intense sunlight, and ground texture can only be seen in the shadows.

Is there an example of a painting using textural techniques?

This painting, *Urban III*, by Sandra Walker, is all about texture. Each of the various kinds of surface have been treated with different textures, including the doors, the plaster, and the brickwork. At the same time, the accurate recording of detail has served to give an almost photographic sense of realism.

Pale grey washes support textural overpainting and plenty of spatter.

The original mottled brown texture of the door has been scratched and lifted off in places.

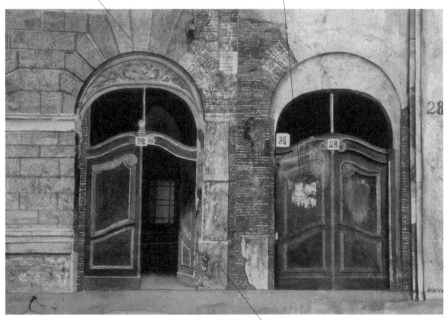

Above: Urban III, *Sandra Walker.*

These large stones have been treated with a coarse texture to suggest sandstone blocks that have been weathered over the years.

What is line and wash?

Particularly popular with illustrators, line and wash involves outlining a drawing with ink and using color wash to pull the illustration together. The line takes on a descriptive role and becomes the binding factor, freeing the wash to extend beyond its normal boundaries without the need for hard edges, and allowing the wet-in-wet properties to be exploited fully. The line can be pencil, ink, or paint, and applied with dip pen, fountain pen, or brush. Hot-pressed paper is the easiest surface for line work because of its smoothness. Washes should be pale to give the line extra emphasis. Black lines should not be heavy but delicate and refined; sepia or brown lines are more subtle.

Below: Cornish Village, *Tom Groom.*

Line is used in a textural way by loosely scribbling and hatching across the surface.

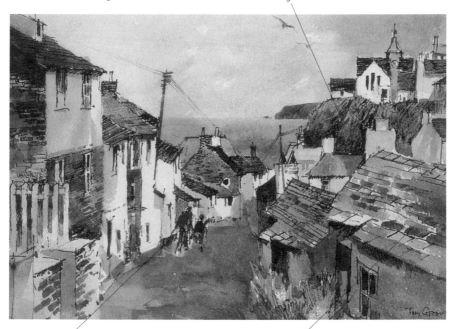

The center of interest is indicated by the strongest color, a reddish brown. The line work is loose and expressive, to convey a sense of movement as the figures walk down the hill.

The detail is shared between the washes and line work. Small washes describe most of the detail, with loose lines used to provide consistency.

What is brush drawing?

Brush drawing literally uses the brush to describe the subject. Expressive and fast, it is ideal for sketching, or it can be used to complete a painting, and works effectively in conjunction with washes. The brush produces modulated and energetic lines which are good for portraying movement.

A flexible, pointed brush is the most suitable for this technique, sable being preferable because it combines softness, firmness, and flexibility so that when you lift it off the paper it springs back into shape. For brush drawing, you will need to be able to draw and to keep a flexible wrist. Balance the brush in your hand, midway along the stem, and hold it loosely. As you draw a line, press down on the paper to spread the hairs out and widen the line. A fairly concentrated but fluid mixture of paint and water is best for solid lines, and you can achieve an interesting variation using the dry-brush technique.

Using a rigger

This painting consists of two basic ingredients: flat washes applied with a mop brush, and linear detail, achieved with a size 1 sable rigger, which was ideal for describing the many folds and creases of the evening dress.

1 Use mop brush to paint a mix of violet and Payne's grey over the background in energetic diagonal strokes, allowing the paper to break up the paint. Paint around the figure's outline freely; overlapping is acceptable.

2 Using the same mop brush, block in dress with diluted black. Suggest skin and hair with mixes of Naples yellow, Venetian red, and burnt umber. Use a rigger, and vary the lines when painting the folds in dress with indigo.

3 The line work gives the dress definition and suggests the smooth, shiny qualities of the satin fabric. Indicate the shadows with a few small washes of indigo, which also help to balance out the line work.

4 Use expressive line work to paint the wavy hair in burnt umber and black. Follow this by carefully painting in the features, using a minimum of brushmarks.

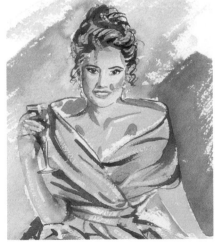

5 Paint the glass simply, using indigo on the glass handle and burnt umber with black for the liquid. Don't overwork it; too much detail here would overemphasize a secondary part of the composition.

6 Paint highlights on the folds of the dress in opaque white with the rigger. Use thick paint in a dry-brush style. Add cadmium red to suggest a blush on the cheeks and a few white highlights on face, hair, and glass.

How are watercolor and soft pastel used together?

The striking brilliance and grainy texture of soft pastel contrasts effectively with the smoothness of watercolor. Sparkling broken colors can be achieved by overlaying watercolor wash with light strokes of pastel, particularly on fairly rough paper. Use the paint in strong, positive washes. Also, experiment with using a dry-brush technique: the broken effect combines well with the pastel.

1 Lay a flat wash of ultramarine over the whole picture, except the fire. With a No. 7 brush, work indigo into the wet paint for the darkest shadows. Paint the flames in cadmium red and yellow. Paint sepia washes over the darkest shadows and to define the details.

2 When the paint is dry, use cadmium red and yellow soft pastels to suggest the reflections of the flames around the room. Use emerald green, ultramarine, and burnt umber in the carpet and shadows. Apply the pastels with light, feathery strokes in a textural fashion.

3 The grainy pastels suggest the flickering light, and so perfectly capture the atmosphere of the room.

How does mixed media work together in one painting?

Studying paintings which explore a range of media helps you to understand the potential of each technique. Watercolor, body color (see *How is body color used in watercolor?*), and color pencils were used in Read's *Sunlight on Trees*.

The watercolor was first laid in blue–grey washes with a limited palette. These provide the underlying tonal structure. The color pencils and body color were applied over this to provide the splashes of vivid color.

The tree trunks were blocked in with yellow color pencil, broken at intervals by areas of shadow.

Watercolor was used for the pale background washes. The tree trunks were silhouetted with darker washes.

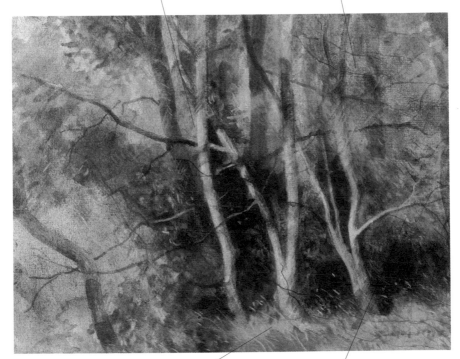

Above: Sunlight on Trees, *Maurice Read.*

Individual streaks and dashes were made with several different color pencils, to suggest grass.

Small flecks of body color were scumbled between the tree trunks to suggest undergrowth.

How is body color used in watercolor?

Body color simply means opaque, water-based paint. In the past, it was usually applied to Chinese white, either mixed with transparent watercolor in parts of a painting or used straight out of a tube for highlights. Nowadays, it is often used as an alternative term for opaque gouache paint.

"Translucent" is perhaps the most accurate way to describe watercolor, as there is a range of pigments, from very transparent to opaque. Chinese white, for example, sits at the opaque end of the spectrum. Opaque water-based paint such as gouache can be used alongside watercolors, adding extra qualities without spoiling the overall luminosity. Observe the difference when the paint is dry. Opaque paint sits on the surface, while a transparent wash recedes, giving a feeling of space.

Opaque highlights

Using body color for opaque highlights allows the initial deep-toned background washes to be laid down freely in the knowledge that lighter colors can easily be added later, so delaying those decisions until the final stages, when an overall assessment is easier to make. As a result, a few selective highlights can be added without diminishing the effect of the deep shadows.

Body color

Chinese white mixed with other colors in concentrated form produces more covering power; when it is more diluted, it simply modifies colors into paler and more pastel hues, an effect that is very pleasant and is worth exploring.

Gouache offers a more concentrated and brilliant white, with a chalky texture. Gouache is the better choice if you want to achieve a thick consistency.

You can extend into the full range of gouache paints, working opaquely over washes, which will enable you to work from dark to light. If you include gum Arabic with gouache, you can build up rich, translucent glazes.

1 The main background wash is ultramarine and alizarin violet, with burnt sienna to one side. When dry, apply washes representing foliage in mixtures of yellow ochre, sap green, and ultramarine, and a little burnt umber.

2 Block in the large banana leaves with a mix of ultramarine and yellow ochre, and extend down into the creepers using a darker version of the same color. Paint the dark leaves in the center in indigo. When dry, overpaint the cast shadows of the banana leaves.

3 Note how the shadows of the overlaid blue banana leaf have partially dissolved the dark creepers. The darkest areas of the foliage, painted in indigo, are situated in the bottom right, counterbalancing the bright top section. The darkest tones are mainly complete.

4 Mix permanent white gouache with cadmium yellow and a small amount of water using a No. 4 sable. Paint on to the upright leaf. Add sap green to the mix, and apply highlights to the foliage. Paint highlights on the leaves with white and a touch of yellow.

5 The result is full of contrasts, with a few well-placed highlights over the diagonal shadows to convey strong sunlight. The triangular composition and strong diagonals give a dynamic feeling to the painting, with a sense of life and warmth.

How is scraping used in watercolor painting?

Sometimes called "sgraffito," scraping back simply means removing dry paint so that the white paper is revealed. This method is often used to create small, fine highlights. Considering the delicacy and finesse of watercolor painting, it is a surprise to discover how tough watercolor paper is and how much punishment it can take. When you scrape back, you will alter the surface texture, but even this can be turned to your advantage, as a roughened paper surface is very textural — so don't be afraid to get rough!

You may have to make important decisions as you come to the end of a painting and discover mistakes. To correct errors or alter an area so that it works better, you can scrape off the paint and possibly the top layer of paper as well. A scalpel point will scratch out fine lines or small areas. If you want a crisp edge, lightly cut into the paper over the outline: this is safest with heavy paper. A curved blade has the benefits of both a fine point for scraping out detail and a curved edge to scoop out broader areas. A razor blade is good for large areas, but double tape over one edge for safety.

Scraping back works best on a dry surface because a damp surface will "fur up." Don't try to cut too deep with the first stroke, but do several light strokes; in this way, you will cause minimum damage. Blunt blades will tear the paper.

Left: *Large areas of paint can be scraped back with the flat of a knife blade or razor blade. This only removes the raised tooth of the paper, leaving color still in the "troughs," which creates a mottled, broken color effect.*

What is knifing out?

The principle of knifing out is that the blade has a squeegee effect, compressing the surface and pushing the paint to one side, where it collects. For flexible lines, use a pointed painting knife. If you hold it on its side, you will also be able to remove large areas of paint. A palette knife, with its rounded point, creates wider lines. For even bigger areas, a credit card works well; an old credit card can be cut to any size you require.

Timing is crucial. If you knife a fine line when the paint is very wet, a dark line will appear because the paper will be bruised and the paint will flood into the groove (although a large area will displace all right). To get a white line out of the paint, it must be damp; the paint will then evacuate the groove, leaving an almost clean line.

This is a good clean way to create the illusion of grass, branches, or hair in wet paint, in a convincing and spontaneous way. This effect is hard to reproduce with a brush, and has a pleasantly textured edge, resulting in natural cohesion with its surroundings.

A paintbrush handle also provides a convenient instrument for scoring impressions on the paper. This effect can be further accentuated by adding a little gesso to the paper, which can be worked into with a knife and, when dry, makes an excellent surface for overpainting with watercolors.

1 Use a plastic spatula to apply gesso to the areas that you want to scour into (stonework, vegetation, etc). While this is wet, use the end of the brush handle to make linear impressions in the gesso, then let it dry.

2 Paint over the stonework with yellow ochre, viridian, and brown madder alizarin, painting directly over the dried gesso areas, as you would paper. The lines appear dark as the paint settles into the grooves.

How do I use a painting knife?

A painting knife can be used to scrape out highlights or lighter areas, creating some key directional lines, which suggest detail and add movement without being obtrusive in a simple painting. It is an excellent way of avoiding painstaking brushwork, which carries the danger of overworking and deadening the paint.

1 Using Prussian blue, yellow ochre, and a little burnt sienna, paint the background, face, hair, and shirt. Let this sink into the paper and, while it is still slightly damp, lightly scrape out highlights with the tip of a painting knife.

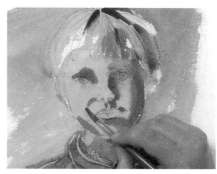

2 While the underpainting is still damp, use a No. 9 brush to paint in some shadows on the face with burnt sienna and into the hair with burnt umber. Some slight softening of the edges will occur.

3 The darker paint on the hair makes an ideal surface from which to knife out strands of hair. If you knife out while the paint is too wet, it will flood back into the groove, leaving a darker line, which can be an advantage here.

4 This close up shows the soft serrated edges of the knifed-out lines, in keeping with the overall effect. The knife's flexible blade can also be used to achieve curved, tapering lines.

What is glazing?

Glazing is an effect created by applying transparent paint in an overlapping manner that generates a third color, just as overlapping a piece of red cellophane with a piece of yellow generates an orange color. Gum Arabic is an excellent glazing medium, imparting a glossy varnish to the surface which enriches the color further.

There are a number of secrets for success: always ensure that the first layer of paint is dry before glazing; use the most transparent colors and don't overwork them; use a light touch when applying the overlapping colors; staining colors work best as the first color used; and always dilute gum Arabic, otherwise cracking may occur. Experience will teach you how much dilution is needed; but, as a general guide, there should be considerably more water than gum.

Below: Tuolumne Pool, *Dan Peterson. This painting shows clearly how you can glaze over a whole area of detail without disturbing the underlying pigment and yet completely change the effect. The glazing demonstrates the transparency of watercolor, fully exploited to create richness and a truly convincing illusion of depth.*

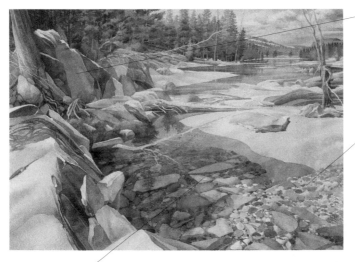

The deep blues of the rocks are achieved by superimposing several layers of paint.

All the pebbles were this color before the final glaze was applied over those in the center. The unglazed pebbles are much paler and the whites are still evident.

To create this rock pool, the pebbles were painted first. When they were dry, a warm mix of paint was quickly washed over, leaving out the tips of a few boulders, which protrude above the surface.

How is gum water used?

Gum water, which is simply gum Arabic diluted in water, adds a certain richness to watercolors and keeps the colors bright. It can also be used, as it is here, as a sort of resist method to create highlights in the watercolor.

1 The tree and hedge are painted in with pure watercolor greens.

2 A further wash of green is applied, this time mixed with gum water.

3 The area of the central tree is spattered with water, which is flicked on with a household brush.

4 The central tree is blotted with a rag, so that where the water touched it, small areas of paint lift off, the gum being soluble in water.

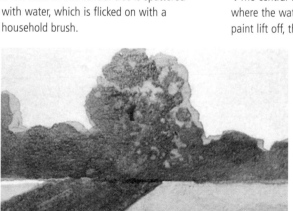

5 The lighter patches of color give an extra sparkle to the tree, while the addition of the gum water imparts richness to the dark green on either side.

What is ox gall liquid?

Ox gall liquid is a wetting agent that increases the volatility of watercolor and causes it to flow more freely. It will cause the paint to blend in unpredictable ways, creating exciting effects.

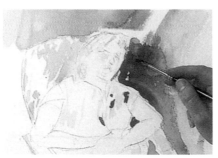

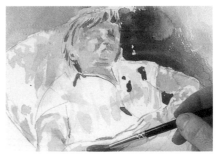

1 Paint the background with Prussian blue, in a loose, broken wash. Mix ox gall liquid with Prussian blue and add this wet-in-wet to the wash in several places. Accelerated bleeding and fusion of paint will occur in those places.

2 Add more Prussian blue and a mix of Winsor green and raw sienna, both with ox gall liquid, to the background. Build up the skin tones. Paint cerulean blue on the chairs and clothes.

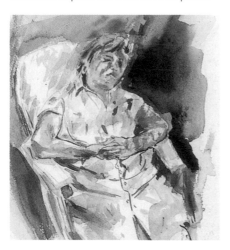

3 The action of the ox gall liquid is more evident on the background, with some dramatic effects. There is an interesting paradox between the man resting and the dynamic tension expressed in the brushwork.

How is dishwashing liquid used?

Dishwashing (washing-up) liquid is a matte version of gum Arabic. It slows down excessive fluidity in wet-in-wet painting. If it is overworked, it will froth up, but this frothing will subside as it dries. Its overall effect is to create a soft-focus painting, with a blotchy finish, which can be useful.

Always use a clear, colorless dishwashing liquid for this technique.

1 Mix permanent green deep with undiluted liquid. With a round brush, paint foliage. As the paint dries, the pigment creates a granulated texture.

2 Before foliage has dried, paint door with Winsor blue and dishwashing liquid. The two will blend slightly, resulting in a soft, furry edge.

3 Paint shadows of vines in Winsor blue with alizarin crimson and dishwashing liquid. Paint door shadow with Winsor blue and black.

4 Overpaint greenery with a darker mix of color and dishwashing liquid. Suggest a few leaves and vary the intensity of the color.

5 Mix alizarin crimson, Winsor blue, and black, paint pergola, letting it fuse with the vine. The resulting blotchy texture diminishes a little on drying.

6 Use the dishwashing liquid to control the paint and also increase the paint's transparency, making it suitable for glazing.

What is pouring color?

Artists using the pouring color technique pour large qualities of diluted watercolor paint over pre-masked areas of paper. Then the paper is tilted, mingling the color into unique patterns. The results leave a surprising effect when dry, which is further enhanced when the masking is removed.

There are several tips for success when using this technique. Ensure that you stretch the paper or, better still, use a heavier paper, over 200 lbs (90 kg), to avoid buckling. Always mix large amounts of your pouring colors so that you do not run out in the middle of pouring. Direct the cool colors toward the darker, shadowy areas and warm colors toward the light, bright areas. Subsequent poured layers should continue in this way in order to avoid muddy blends and to maintain harmony. Bear in mind that the sections that receive a second wash will become deeper and more intense, while those defined by just one layer remain bright and transparent.

Although this challenging technique takes skill, planning, and some trial and error, the results are stunning and quite unlike anything else that can be achieved using other techniques in watercolor painting.

Above: *Here the pouring technique is demonstrated to great effect. With the drawing complete, areas are reserved with masking. The paper is laid flat and mixtures of three staining primaries — red, blue, and yellow — are poured over, targeting warmer or cooler areas. The mixtures are given time to stain the paper and then poured off, creating a stunning, glowing background over which details can be added.*

5
STILL LIFE

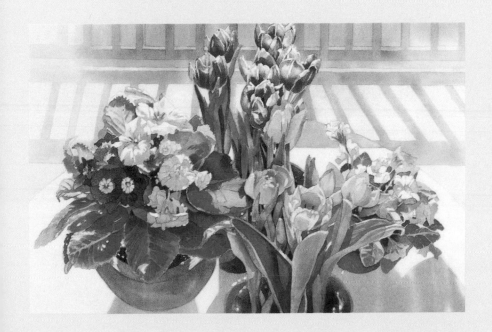

What is still life?

Still life, as its name implies, simply means a composition of objects which are not moving and which are incapable of doing so, usually arranged on a table or decorative surface. The French, rather bleakly, called it "dead life."

Paul Cézanne (1839–1906) used still life to explore the relationships of forms and their interaction on various spatial planes. Cézanne usually worked in oils, but the painting below shows his understanding of watercolor.

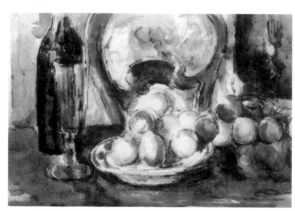

Left: Still Life with Chairs, Bottles, and Apple, *Paul Cézanne. He used still life to explore the relationships of forms and their interaction on various spatial planes.*

Should I choose unusual subjects?

The subject can be whatever you like, but traditionally the objects in a still-life group are in some way associated with each other — a vase of flowers with fruit, a selection of vegetables with cooking vessels or implements, and sometimes dead fish, game, or fowl with a goblet of water, perhaps, or a bunch of parsley. Culinary still-life paintings are less popular nowadays, possibly because they run the risk of looking like the cover of a cook book.

Good paintings can be made from quite homely subjects. Vincent van Gogh (1853–90) made a wonderful still life from nothing but a pile of books, *Still Life with Three Books.*

Look around you at the objects and colors that inspire you; consider light, texture, and tone. Sometimes the addition of a small detail, such as a ruched cloth or a draping curtain, can provide variety in texture or hue, and bring the composition together.

Is there an advantage to using the still-life format?

Your ability to control the subject of a still life means that you can take as much time as you like to work out the composition and complete the preliminary drawing. Additionally, you can practice watercolor painting techniques at leisure, trying out new ones as you feel inspired.

Inexplicably, watercolor was seldom used in the past for still life, other than flower paintings, but it is now becoming extremely popular.

How do I start a still life?

The real challenge is arranging your still life. This may take some time: dumping an assortment of items down on a table will not create a good composition.

The best rule to follow at first is to keep the composition simple. The more objects you have, the harder it is to arrange them in a harmonious way. It is also best to have a theme: if the various objects are too different in kind, they will look uneasy together.

Start with something you like and keep re-arranging until you are satisfied that you have achieved a good balance of shapes and colors. Many artists make sketches to work out the structure of their composition.

When you think it is right, look at the composition through a viewfinder (see *How do I make a viewfinder?*) to assess how well it will fill the space. Move it around to consider several possibilities.

Left: Plums, *William Henry Hunt. Plums is an unusual approach to still life, as it has an outdoor setting, but was almost certainly done in the studio from preliminary sketches. Hunt produced charming portraits as well as genre subjects, using dry paint to depict colors and textures with great accuracy.*

What are some practical considerations for setting up a still life?

Lack of space in which to paint is often a problem for the amateur artist, but still-life painting provides plenty of scope. The egg box below, for instance, is a challenging subject that occupies little space. Simple in theme, its differing contours and textures encourage the artist to produce a sensitively wrought piece of work.

Lighting is also very important. It defines the forms, heightens the colors, and casts shadows which can become a vital component in the composition.

If you are working by natural light other than a north light, it will change as the day wears on. This may not matter if you decide where the shadows are to be at the outset and if you do not keep trying to change them; but, often it is more satisfactory to use artificial light. This solution sometimes brings its own problem, however, because if you are painting flowers or fruit they will wilt more quickly under a hot light. You may simply have to decide which is the lesser problem for your work.

Above: Egg Box, *Charles Inge. This subtly toned watercolor of eggs in a box shows how the simplicity and delicacy of the egg forms can be retained while the more sturdy but intricate structure of the egg box is also effectively handled. The shadows cast by the box anchor it firmly on to the surface. This is an important factor when a light-colored background is used: it is essential that the object should be given the appearance of stability and solidity.*

Should still-life arrangements have a theme?

Most still-life paintings have a theme which unifies and makes sense of the different objects in it.

With its challenging surfaces and great textures, the kitchen provides many suitable subjects in the way of crockery, utensils, or food; flowers or fruit provide scope for including small insects, wasps, or butterflies. Consider cutting the fruit to open up further challenges in form, tone, and texture.

Outside the more usual range of subjects, groups may present interesting color themes and juxtapositions of shapes and tones, so that bizarre and unlikely items can be incorporated into successful still lifes: as an exercise, consider painting tools or bottles.

How do I build in harmonious color into a still life?

Think of the painting process as a search for the right colors and values. Try to focus on the planes of colored shapes made up of dark, light, and middle values rather than spaces that need to be filled in. Check that the first washes are light in value, establishing a "roadmap" for the rest of the painting. These fluid washes also dampen the surface so that subsequent applications of color are intense and soft-edged.

Work around the entire picture as you paint each layer to ensure that one area does not dominate the others.

1 Make small watercolor sketches to evaluate the layout, composition, and colors. Consider both a vertical and a horizontal format for the painting, and make a grey-and-white value sketch to check the arrangement of values.

2 When you have selected your composition, make a larger drawing on watercolor paper and apply the first diluted color washes of harmonious color with 1.25 in. (3 cm) and 2 in. (5 cm) flat brushes.

How are related colors balanced?

Some artists limit the number of colors that they work with in order to a create harmony through a palette of related colors. Each new mix is a combination of the colors already in use. This ensures that harmony is maintained within the painting and that any shifts toward red, blue, or yellow are more apparent.

Always mix plenty of your chosen color blend so that you do not run out in the middle of painting. Have a good amount of pigment in your brush when you touch it to the surface of the paper. Too much water in the mixture may cause you to lift off paint when you're trying to lay more on.

1 When the pencil drawing is complete, apply masking fluid in selected areas. Work pale, warm washes of yellow ochre, Chinese white, reds, and blues over the paper.

2 Paint pale washes of yellow ochre mixed with Chinese white, adding small amounts of reds and blues. Establish areas of color with loose washes of red, green, blue, and ochre.

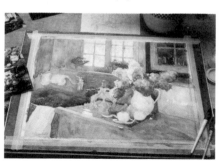

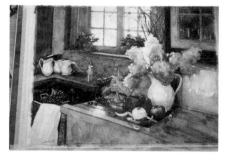

3 Now, begin to get more specific about colors and values, reflecting light and shadow. Let the colors mix harmoniously on the paper.

4 Paint each object, removing paint with a bristle brush as required to lighten values and soften highlights.

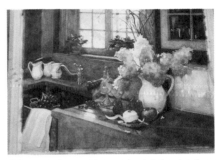

5 Add texture by covering most of the painting with tracing paper, having removed panels as required, then spattering paint from the edge of a stiff toothbrush on to the uncovered areas.

6 Remove the masking, and paint the details and darkest values. It is not necessary to finish everything to the same degree: it is more interesting if some areas are less well defined.

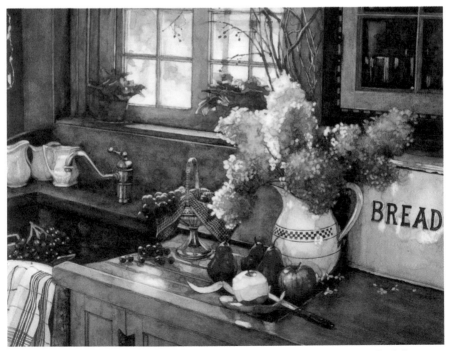

7 Wash warm colors over the flowerpot in the window, and paint darker tones into the light areas near the board under the grapes.

Is there a good example of floral still-life painting?

This watercolor, *Spring Flower*, by Jean Grastorf, is an excellent example of a floral still life, executed with high quality painting. The steps provide detail as to how the artist approached the painting and demonstrate the use of the pouring color technique.

The artist works from photographs and sketches to make a value study of the picture. She then creates a full-scale drawing on tracing paper, before transferring the image to a sheet of watercolor paper that she has soaked, stapled to board, and allowed to dry thoroughly. At this point, she masks predetermined areas of the paper.

Grastorf dissolves the three staining primary colors in water, preparing stronger mixtures of yellow because the red and blue pigments can overwhelm it. She mixes a large amount of all three paints so she does not run out. The artist soaks the prepared paper with clear water, and then pours the three colors across it. She holds the board flat so the pigment can soak into the paper and then pours off the excess. As Grastorf pours, she directs the cool colors into the shadowed areas of the picture and the warm colors into the sunlit sections.

When the first layer of color is dry, Grastorf removes masking from some parts of the painting and applies it to others. She then pours a second layer, adding warm colors over warm colors, cool over cool, to maintain harmony and avoid muddy blends. The sections that receive the second wash become deeper and more intense, while those defined by one layer of color remain bright and transparent.

Paper

Grastorf uses a heavy Waterford rough paper because of its bright white surface and ability to hold washes. She soaks the paper for ten minutes in a tub of water, staples it to a board, and then tapes around the edges.

Palette

It is important to have fresh color. If the paint dries and you try to reactivate it, you will not get the kind of clean, transparent color you need.

1 A value study helps to evaluate the shapes and indicates where to apply the mask. A full-size drawing is made on tracing paper.

2 Masking fluid is applied to block the backlit leaves, the flowers in the sun, and the areas that require special color attention.

3 The paper is laid flat and primary color washes are poured over the image, given time to stain the paper, then poured off.

4 When the paint is dry, some masking is removed to expose white paper. Masking fluid is painted over other patches of the first wash.

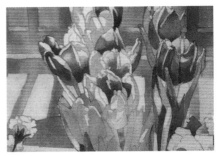

5 The pouring color technique is repeated using a second batch of colors. When the paint is dry, all the masking is removed.

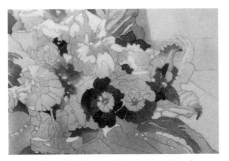

6 Detail is added by applying paint directly using a rounded paintbrush.

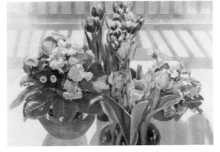

7 The artist has created a bold and vibrant painting, using the pouring technique to avoid the muddying effect of successive washes.

6
LANDSCAPE

What is the English Tradition in landscape art?

In England, the country which more than any other can claim to have founded the great tradition of landscape painting in watercolor, landscape was not really considered a suitable subject in its own right until the late eighteenth century. The classical landscapes of the French artists, Claude Lorraine (1600–82) and Nicolas Poussin (1594–1665), were much admired by artists and discerning collectors, as were the realistic landscapes by the Dutch school artists such as Jacob van Ruisdael (1629–82), but the public wanted portraits and historical subjects.

The great English portrait painter Thomas Gainsborough (1727–88), had a deep love of his native landscape and regarded it as his true subject; but, in order to earn a living, he painted many more portraits than landscapes.

The two artists who elevated landscape and seascape to the status of fine art were J. M. W. Turner (1775–1851) and John Constable (1776–1837).

Left: Landscape with a Church beside a River, *Thomas Girtin. Much admired by his contemporary, Turner, Thomas Girtin was a pioneer of watercolor. He worked with only five colors — black, monastral blue, yellow ochre, burnt sienna, and light red — to create subtle evocations of atmosphere.*

The influence of these artists on painting, not only in Britain but all over the world, was immeasurable. By the early nineteenth century, landscape had arrived, and, at the same time, watercolor, a medium hitherto used for quick sketches and for coloring maps and prints, had become the chief medium for many landscape artists. Constable used watercolor as his predecessors had, as a rapid means of recording impressions, but Turner used it in a new and daring way, and exploited its potential fully in his landscapes, in order to express his feelings about the light and color he perceived in the scenes before him.

What problems may be anticipated when painting outdoors?

Watercolor is a light and portable medium, ideally suited to outdoor work, but *al fresco* painting in any medium always presents problems. Chief among them is the weather. The blazing heat dries the paint as soon as it is laid down, the freezing winds numb your hands, the sudden showers blotch your best efforts, and the changing light confuses you and makes you doubt your initial drawing and composition.

If the weather looks unpredictable, take extra clothes (a pair of old gloves with the fingers cut off the painting hand are a help in winter), and a plastic bag or carrier large enough to hold your board in case of rain. If the sun is bright, sit in a shaded place, otherwise the light will bounce back at you off the white paper, which makes it difficult to see what you are doing. Take sufficient water and receptacles, and restrict your palette to as few colors as possible.

Choose a subject that genuinely interests you rather than one you feel you "ought" to paint, even if it is only a backyard or local park. If you are familiar with a particular area, you will probably already have a subject, or several subjects, in mind. In an unfamiliar place, try to assess a subject in advance by carrying out a preliminary reconnaissance rather than running straight out with your paints.

Work as quickly as you can without rushing, so that the first stages of the painting are complete before the light changes too much. If necessary, make a start on one day and complete the work on the next.

Seascapes are especially difficult, because the color of the sea can change drastically in a matter of minutes. It is often advisable to make several quick color sketches and then work indoors from them.

How is aerial perspective used in landscape painting?

Also known as atmospheric perspective, aerial perspective is a subject which is of particular concern to the landscape artist. This painting, *River Landscape,* shows how diminishing tones and distant blue mountains give a depth to the work which is convincing; we see it not as a hillside and mountains painted on a vertical picture plane, but as a landscape stretching away from us.

Objects in the foreground are stronger in tone and tonal contrasts within themselves than objects in the middle distance, and these in turn are stronger than objects in the far distance. This difference in tone is the result of haziness caused by dust particles, mist, and other effects of weather. As tones lessen in strength, they take on an increasing blueness; as in the case of *River Landscape*, a far distant range of hills is likely to be seen as a limited scale of light blues and blue–greys. Middle distance fields will be seen as greenish–blue and foreground features will exhibit the range of color and tone.

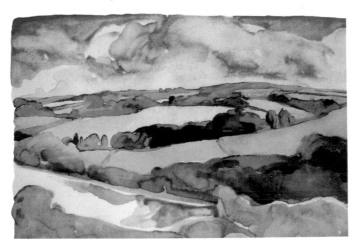

Above: River Landscape, *Marc Winer. A landscape such as this is notable for the fact that it relies for its impact and dramatic effect on purely natural features. An artist will often include a group of buildings, or architectural features such as a church spire, to provide interest. In this case, however, there is plenty of variety in the rolling hills, colors of fields, shadows from the trees and, most importantly, the river with its reflections of the dramatic sky.*

How do I paint trees and foliage?

Trees are among the most enticing of all landscape features. Unfortunately, they are not the easiest of subjects to paint, particularly when foliage obscures their basic structure and makes its own complex patterns of light and shade.

To paint a tree in leaf successfully, it is usually necessary to simplify it to some extent. Start by establishing the broad shape of the tree, noting its dominant characteristics, such as the width of the trunk in relation to the height and spread of the branches. Avoid becoming bogged down in detail, defining individual shapes in a manner that does not detract from the main mass. If you try to give equal weight and importance to every separate clump of foliage, you will create a jumpy, fragmented effect. Look at the subject with your eyes half closed, and you will see that some parts of the tree, those in shadow or further away from you, will read as one broad color area, while the sunlit parts and those nearer to you will show sharp contrasts of tone and color.

Lifting out is a useful technique for highlighting areas while avoiding hard lines. Sponge painting suggests the broken color effect of foliage. Dry brush is another technique well suited to winter trees with delicate twigs.

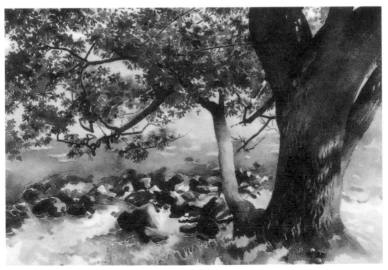

Above: Lakeland Tree, *Moira Clinch. In this watercolor, Clinch has used a combination of wet-in-wet and wet-on-dry, which gives excitement and variety to her paint surface.*

How does light affect a landscape painting?

Light plays an important part in determining the atmosphere of your landscape painting, and watercolor, with its characteristics of fluidity and transparency, is ideally suited to capturing its effects. As well as creating the general mood of a picture, light may be responsible for dramatic effects: strong light gives rise to deep, dark shadows, or an unusual quality in the light may produce a weird glow (see *What are the characteristics of shadows and light?*).

Locational light

Geographical location is one of the major factors affecting the quality of light. Paintings made in the hot intensity of southern light is in marked contrast with the coolness emanating from pictures painted under a northern sky.

The time of day is also important. The qualities of thin, early morning light, of midday sun high in the sky, or of a rich, warm evening light, can totally alter the scene you are painting. A midday sun produces short shadows; a setting or rising sun creates long shadows with warm or cool tones.

Weather

General weather conditions will affect the quality of light: a cloudy, overcast sky gives a dull, thin light; dramatic clouds produce strong shafts of light piercing through. Dramatic weather

conditions do not appear to order. It is advisable to always be prepared, perhaps carrying a sketchbook and small box of paints. Even an ordinary notebook is useful; weather conditions can be recorded and copious notes made so that a study can be painted later in the studio.

Even under normal conditions, light can change very quickly, and it may be necessary to work extremely fast (see *How do I cope with the changing light?*). On a summer's evening, for instance, fast-lengthening shadows and the sinking sun will make it necessary to pace your work accordingly and not to attempt too detailed an interpretation of your landscape. As far as choosing a palette is concerned, only practice and experience will tell you which range of colors is best suited to certain effects.

1 Make an accurate drawing, positioning the horizon carefully. Lay the sky color first, as everything else will be darker, using a variety of blue and Naples yellow to cut intensity.

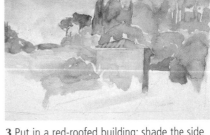

2 Add plenty of water to the building color to give the effect of age. Block in greens, cutting the intensity with ochre, sienna red, and cadmium yellow.

3 Put in a red-roofed building; shade the side with sienna red, Naples yellow, emerald green, and cobalt violet deep. Use lots of water to paint pines. Don't make them too regular.

4 Use sienna red cut with emerald to put shadow under the roof, and deepen textures on the roof and face of the building with subtle, warm earth tones. Redraw the church in the background. Place darks all around the picture, and insert foreground color.

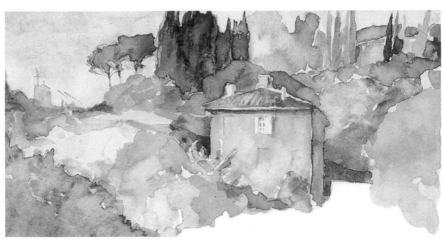

Above: House among Trees, *Marc Winer. Subtle, hazy light suffuses this painting.*

How is watercolor especially suited to painting skies?

Large, expansive skies have played a prominent part in the history and tradition of watercolor. They can feature as a backdrop to your painting or play an integral part, lending drama or indicating vastness. Because the source of light is generally in the sky itself, it follows that this will be the area lightest in tone in the landscape. It is necessary, however, to integrate the sky with the overall tonal scheme of the painting, and you may find yourself adjusting either the sky or the land accordingly.

The fact that watercolor artists have had such a propensity for painting skies is due to the nature of watercolor itself. It lends itself well to this subject: the unpredictability of wet-in-wet washes, the transparency of the medium, and the possibility of coming up with a happy accident all contributing to the range of effects that can be achieved. It is possible to create a sky by means of a single flat wash, but much more likely that it will be the result of many overlaid washes and exploratory workings.

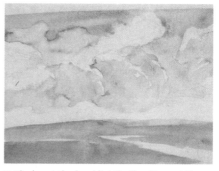

1 There are two methods of drawing clouds: either from a photograph, extremely accurately, or by sketching to get the general effect — the rhythm of the clouds and the shapes in between. Start painting in the clouds, working horizontally, then drawing the brush around the shape to pull it into the picture.

2 Block out the land lightly. The distant hills are darker than the foreground, but they will be overlapped, so are put in first. Keep the middle ground fairly light — olive green with burnt sienna to cut intensity. Pick out some of the darker shapes in the clouds: a tiny bit of pink indicates light from the land.

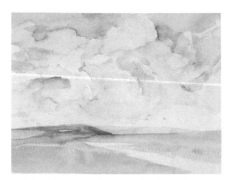

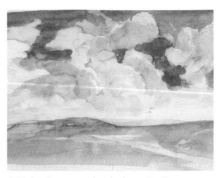

3 Put middle tones into the clouds, adding Payne's grey and other colors to make them more three dimensional. Deepen tone in the area of the horizon; some small clouds here will help the overall perspective.

4 Make the storm clouds dramatic. Drop some shadows into the foreground and stripe the land with shadows. Unify some of the clouds by making them bigger and less fragmented.

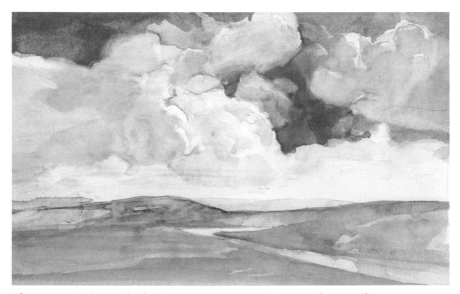

Above: Low Horizon with Clouds, *Marc Winer. Note the contrast between the small sharp-edged clouds and the more diffused edges of the larger shapes.*

What techniques are suggested for painting clouds?

It is always worth taking the trouble to sketch and paint skies and clouds from life, even if you do know some tricks and formulas for painting skies, because the sky is so important in a landscape painting. A slick, mannered, all-too-perfect sky is devoid of any excitement or intensity, whereas a sky painted from direct observation will always reveal something of the artist's emotional response to the subject.

Watercolor lends itself perfectly to reproducing the amorphous, translucent nature of clouds. Keep your colors as fresh and transparent as possible: don't constantly rework them — too much mixing makes them look lifeless. If you find an area is becoming overworked, it is better to start again. Similarly, make your brush strokes as unlabored as possible, and don't be afraid to load your brush with plenty of color. Remember that watercolor is lighter dry than wet.

Many cloudy skies will start with the laying of a background color wash. It may seem a simple enough technique, but if you want to develop confidence in producing an even wash, you will first need to practice.

With watercolor, it is possible to leave the highlights as unpainted white paper. The lit edge of a cumulus cloud often has a crisp, well-defined edge, while the shadows are soft and diffuse. You will need to plan your image beforehand to work out where the hard edges will fall, so that you can wash the background color around them. The soft, ragged parts of the cloud can then be allowed to fuse wet-in-wet with the background wash, making a soft edge. Knowing when to take this step — that is, when the receiving wash has dried enough to prevent the second color from running out of control, but has not become so dry that ugly streaks and hard edges form — takes experience and practice. But with watercolor, even experienced artists are caught out sometimes.

ARTIST'S TIP

It is easy to think of clouds as grey and white, but your clouds will gain luminosity if painted with delicately tinted greys. Use burnt umber and ultramarine as a darkening agent, instead of black. Add water to lighten the color, and yellow ochre or cadmium red for yellow– or pink–greys.

Technique Study: Painting Clouds

1 You need to work fast. As soon as the wash is completed, use a crumpled piece of tissue to gently dab off the blue paint. Apply slightly more pressure to define the clean edge of the brightly lit top surface of the cloud.

2 Once you have established the outline, reshape the tissue and use it to lift off the main body of the cloud. Take care not to rub the paper or you will damage the surface; use a press-and-lift motion.

3 Cloud shadows have appeared, created by the thin layer of blue left by the lifting-off process combining with the yellow ochre wash beneath. To build up these cloud shadows further, apply tinted grey washes using the wet-in-wet technique.

Are fields and hills difficult to paint?

Mountains always make dramatic subjects, and their powerful presence needs only the minimum of help from the painter. Quieter country — flat or with gentle contours — can easily become dull and featureless in a painting. It is seldom enough just to paint what you see, so you may have to think of ways of enhancing a subject by exaggerating certain features, stepping up the colors or tonal contrasts, introducing textural interest, or using your brushwork more inventively. Interestingly, there have been artists throughout history who have believed that they have been painting exactly what they have seen, but they never really were — consciously or unconsciously improving on nature is part of the process.

Part of the problem with this kind of landscape is that, although it is often beautiful and atmospheric, much of its appeal comes from the way it surrounds and envelops you. Once you home in on the one small part of it you can fit on to a piece of paper, you often wonder what you found so exciting — this feeling is well known to anyone who takes photographs. Therefore, take a leaf from the photographer's book and use a viewfinder (see *How do I use a viewfinder?*). With this, you can isolate various parts of the scene and choose the best. If it is still less interesting than you hoped, add elements from another area, such as a clump of trees or a ploughed field, and emphasize something in the foreground.

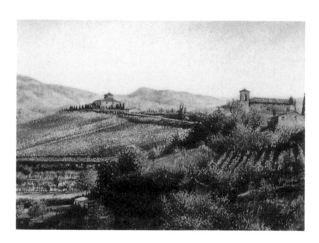

Left: Castello-in-Chianti, Martin Taylor. *Using acrylic white to give body to his watercolor, Taylor builds up his colors and textures gradually, using tiny brushstrokes to create a shimmering quality, and working on one part of the painting at a time.*

Left: Amberley and Kithurst Hill, Sussex, *Robert Dodd. Working in gouache, Dodd has given drama to his quiet subject by the use of bold tonal contrasts and inventive exploitation of texture. He has used his paint quite thickly, building up areas such as the ploughed field by masking and sponging.*

Above: Frosty Morning, Autumn, *Donald Pass. This artist has an unusual watercolor style, using his paints almost like a drawing medium. He makes no preparatory drawing, and begins by laying broad washes of light color. He then builds up each area with a succession of directional or linear brush marks. The brushwork, as well as being effective in terms of pure description, creates marvelous movement: we can almost feel the light wind bending the grass and sending the clouds scudding across the sky.*

Which techniques are used for painting rocks and mountains?

Mountains are a gift to the painter: they form marvelously exciting shapes, their colors are constantly changing, and, best of all, unless you happen to be sitting on one, they are far enough away to be seen as broad shapes without too much worrying detail.

Distant mountains can be depicted using flat or semi-flat washes, with details such as individual outcrops lightly indicated on those nearer to hand. To create atmospheric effects, such as mist or light cloud blending sky and mountain tops together, try working wet-in-wet (see *What is wet-in-wet painting?*) or mixing the watercolor with opaque white.

Nearby rocks and cliffs call for a different approach, because their most exciting qualities are their hard, sharp edges and their textures — even the rounded, sea-weathered boulders seen on some seashores are pitted and uneven in surface. One of the best techniques for creating edge qualities is the wet-on-dry method, where successive small washes are laid over one another (see *What is the wet-on-dry method?*). If you become tired of waiting for them to dry, use a hair dryer to speed up the process. Texture can be built up in a number of ways. The wax resist, scumbling, or salt spatter methods are all excellent.

Left: Welsh Cliffs, *Michael Chaplin RE, ARWS. Light pen lines accentuate the directional brushstrokes used for the sharp verticals of the cliff face, and texture has been suggested by sandpapering washes, a technique that works well on the rough paper the artist has used. The addition of body color to the paint has given a suitably chalky appearance to the cliffs.*

Above: Portland Lighthouse, *Ronald Jesty RBA*. Here, Jesty has worked wet-on-dry, using flat washes of varying sizes to describe the crisp, hard-edged quality of the rocks. He has created texture on some of the foreground surfaces by "drawing" with an upright brush to produce dots and other small marks, and has cleverly unified the painting by echoing the small cloud shapes in the light patches on the foreground rock. This was painted in the studio from a pen sketch. Advance planning is a prerequisite for Jesty's very deliberate way of painting: he works out his compositions and the distribution of lights and darks carefully beforehand.

What are the characteristics of shadows and light?

In order to capture an accurate impression of light in your paintings, you have to be able to judge its quality. This quality can be seen in the color and strength of the light, and the effect it has on our perception of what is before us. There are various factors which affect the quality of the light: the weather, the time of day, the time of year, and of course where exactly you are in the world and how close you are to the equator.

It can be instructive to record in a series of sketches the effect that light changing through the day has on a particular scene. There are various points you notice when you compare them.

Shade and shadows

The light is weaker in the early morning and evening when the sun in low in the sky, so the tonal values are softer and less intense. Such light reduces the limits of tonal range, but it plays up the variety of the middle shades. In contrast, the power of the midday sun pushes the tonal range to its extremes, but you will find it bleaches out the subtle middle tones.

As the sun travels across the sky, shadows alter in length, position, color, and value. Strong light produces dark, hard-edged shadows while soft light produces paler, ill-defined shadows. The sun does not rise as high in the winter, so shadows on the ground are longer

throughout the day. In mid-summer, the sun casts dark shadows at noon and can still be quite strong in the evening, casting well-defined shadows.

Color

Sunlight can cast a cold, blue light in the early morning and a golden or pink light in the evening, which will qualify all the colors it falls on. At these times of day, the colors are softer, graduating from highlight to shadow more gently. In bright sunlight, colors appear more vibrant with few middle shades between highlight and shadow. Sunlight in winter is weaker, with a cool blue cast. Daylight in mid-summer is stronger and warmer.

Outline

You will notice that the weaker the light, the softer the outline an object has. In the light of dusk, even objects in direct light will have soft outlines, while those in deep shadow will be almost indistinct. Bright sunlight produces clearly defined edges where it shines directly on objects.

Tone

Because the sun is not as strong in winter, the tonal variety is narrower than in summer. Sunny autumn landscapes are vibrant due to nature's complementary colors — the blue sky is juxtaposed with the oranges and yellows of the leaves.

How do I cope with the changing light?

You cannot freeze the sun's relentless progress across the sky, so you have to learn to cope with it by working fast. You may find it helps to restrict yourself to working on a small scale, using a large brush and few colors. This will certainly discourage time wasted on detail, but you may not want to produce this type of work. If you don't want to be hurried, you could tackle the shadows first, and build up the painting around them.

Another solution is to paint for only an hour or so at a time, returning at the same time of day until the painting is completed — if you can rely on the weather to remain constant, that is.

If you have to finish your painting in one sitting, amass at the start as much information as you can. Your visual memory can be improved if you concentrate hard and explore every part of the scene as if you were painting it. Study the comparative values, scan the contours, explore the character of patches of light and shadows. Some artists find that sketching these aspects in too much detail impairs the power of the memory. But it helps to do both.

Unless you specifically want to paint a scene in bright sunlight, you will be better advised to paint outdoors on a slightly overcast day, when dramatic changes in the position, shade, and intensity of lights and shadows are less likely to occur (see *How does light affect a landscape painting?*).

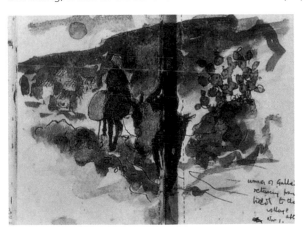

Left: Woman of Galladoro, Sicily, *Ray Evans. Sketches can be used as here to explore the tonal values of a particular time of day. Here, the sky is blue, but the sun is weak.*

Is watercolor suited to painting mist and fog?

Mist and fog heighten the effects of atmospheric, or aerial, perspective on the landscape (see *What is aerial perspective?*). Foreground, middle ground, and background appear more separate and distinct than normal, and objects only a short distance away seem to melt into a haze. In thick fog, even those forms in the foreground appear almost in silhouette, with few shadows to model their contours.

Recession is achieved through decreasing tonal contrasts, particularly in the background, and by overlapping planes. It's a good idea to start at the horizon with pale, indistinct forms, gradually strengthening the shades as you work toward the foreground. Avoid introducing too much tonal contrast and destroying the illusion of mist. You have to strike a delicate balance here.

Fog and mist are characterized by delicate, insubstantial effects, muted colors, and indistinct forms. These qualities need to be treated with sensitivity and a certain deftness; the atmospheric nature of a mist will be lost if the medium is overworked.

Watercolors are naturally suited to representing the transient beauty of mist or fog. The translucence of the medium allows the white of the paper to shine through and create a depth of light which exactly captures misty effects. Allow your washes to flow freely, wet-in-wet, to create swirls of moving mist or receding, nebulous planes.

Background forms can be reduced in shade by painting their shapes, allowing them to dry, and then using a natural sponge dampened with clean water to lift out some of the color.

Also, with watercolor you can capture the softness of form and color by applying paint to damp paper and allowing the forms to blur at the edges.

ARTIST'S TIPS

• Reserve any clear details and dark tones for the foreground; these will enhance, through contrast, the mistiness of the background.

• To enhance the misty effect, a little body color can be dropped into the color washes, making the paint slightly opaque.

Technique Study: Mist

1 On a sheet of dampened paper, pale washes of rose madder are laid in horizontal strokes, starting at the top of the paper.

2 While the paint is still wet, patches of color are lifted out with a small piece of dampened sponge to reveal the white of the paper.

3 The contours of hills are added, using a wash of cobalt blue mixed with light red. The paper is dampened once more to produce the softly dappled color of the sky and water.

Which techniques are used to paint water?

Light on water

The effects of light on water are almost irresistible. Obviously, they can seldom be painted on the spot; a shaft of sunlight suddenly breaking through cloud to spotlight an area of water could disappear before you lay out your colors. But you can recapture such effects in the studio as long as you have observed them closely, committed them to memory, and made sketches of the general lay of the land.

When you begin to paint, remember that the effect you want to convey is one of transience, so try to make your technique express this quality. This does not mean splashing on the paint with no forethought — this is unlikely to be successful. One of the paradoxes of watercolor painting is that the most seemingly spontaneous effects are in fact the result of careful planning.

Work out the colors and tones in advance so that you do not have to correct them by overlaying wash over wash. It can be helpful to make a series of small preparatory color sketches to try out various techniques and color combinations. Knowing exactly what you intend to do enables you to paint freely and without hesitation. If you decide to paint wet-in-wet, first practice controlling the paint by tilting the board. If you prefer to work wet-on-dry, establish exactly where your highlights are to be and leave them strictly alone, mask them, or, alternatively, put them in last with dry opaque white.

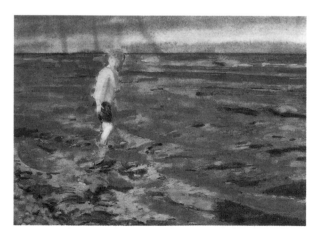

Left: It's Freezing!, *Francis Bowyer. The effect of the low sun on the choppy water has been beautifully observed and painted rapidly and decisively, in watercolor and body color (gouache white). In places, such as the more distant waves, the paint is thin enough for the paper to be visible.*

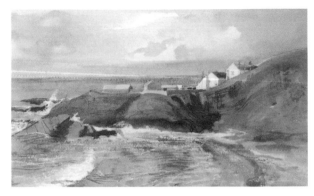

Left: Headland,
*Charles Knight RWS, ROI.
In this atmospheric painting,
Knight has used wax resist
for the waves, and lent
drama to the headland with
dark pencil lines; but, his
techniques remain "in their
place," as no more than the
vehicles which allow him to
express his ideas.*

Moving water

You can never hope to paint moving water unless you simplify it, so learn to make "less say more" by looking for the main patterns in a waterscape and suppressing the secondary ones.

Rippling water under strong sunlight shows distinct contrasts of tone and color. Working wet-on-dry is the best way of describing this edgy, jumpy quality, but avoid overlaying of washes too much, as this can muddy the colors. Masking fluid is helpful, as you can block out small highlights on the tops of ripples or wavelets while you work freely on the darker tones. The lacelike patterns formed when a wave draws back from the beach can be very accurately "painted" by scraping back.

Whichever techniques are used, limit the brush strokes — the more paint you use, the less "wet" the water appears.

Left: The River Guadalupe,
*Shirley Felts. This painting
shows a skillful use of
reserved highlights. Each
pale reflection, sunlit twig,
and point of light has been
achieved by painting around
the area. This can result in
tired, overworked paint; but,
here, none of the luminosity
of the watercolor has been
sacrificed, and it remains
fresh and sparkling.*

How do I paint still water?

Watercolor has an affinity to still water, but poor observation causes paintings to fail. A calm expanse of water is seldom the same color and tone all over because it is a reflective surface. Even if there are no objects to provide clearly defined reflections, the water is still mirroring the sky and will show similar variations. These shifts in color and tone are also affected by the angle of viewing. Water usually looks darker in the foreground because it reflects less light.

Remember that a body of water is a horizontal plane, which, when painted in an unvaried tone, assumes the properties of a vertical one because no recession is implied. Try stressing the flatness and recession by exaggerating a darker tone, or ripples, to pull the foreground forward.

Above: Loch Rannoch, *Ronald Jesty. The artist has enhanced the water surface and banks by setting up strong contrasts of tone while keeping colors muted. The water is not painted flat: a sense of space and recession is created by the dark patch of color in the foreground.*

How do I paint reflections?

Not only do reflections form lovely patterns, but they can also be used as a powerful element in a composition, allowing you to balance solid shapes with their watery images and to repeat colors from one area of a painting in another. The best effects are seen when ripples break up the reflections into separate shapes, with wavering outlines. Try to simplify reflections and keep the paint

fresh and crisp. Let your brush describe the shapes by drawing with it in a calligraphic way.

The amount of detail you put into a reflection will depend on how close it is. A distant one will be more generalized because the ripples decrease in size as they recede from you, so avoid using the same size of brush mark for both near and distant reflections, or the water will appear to be flowing uphill. Emphasize foreground reflections by painting wet-on-dry, and give a softer quality to background ones by using the wet-in-wet or lifting-out methods.

Above: Old Harry Rocks, *Ronald Jesty. In this bold watercolor, the reflection, rather than being incidental, forms part of the focal point. The artist has painted wet-on-dry, and has used the shape and direction of his brushmarks to lead the eye into the center of the picture.*

What is the urban landscape?

The urban landscape can be described as a townscape. A combination of painting and drawing techniques, and a good understanding of perspective, are the keys to successful urban landscapes. Manmade forms demand solid realism.

Remember that the light in towns is different from that of the country: buildings act as obstacles and create dramatic lighting effects. The intimacy of narrow streets can provide focus for your painting, or the contrast in scale, design, form, and texture between ancient buildings and modern skyscrapers.

Above: Balcony in France, *Moira Clinch. A pencil drawing established the spatial relationships before color was applied.*

7
FIGURES

How important is drawing when working with the figure?

As watercolors cannot be reworked and corrected to any great extent, it is vital to start a painting on a good foundation. This means that, before you can paint figures or faces successfully, you must first be able to draw them.

The best way to approach the complexities of the human figure is to see it as a set of simple forms that fit together — the ovoid of the head joining the cylinder of the neck that, in turn, fits into the broader, flatter planes of the shoulders, and so on. If you intend to tackle the whole figure, avoid the temptation to begin with small details; instead, map out the whole figure first in broad lines.

Proportion is particularly important, and many promising paintings are spoiled by an overly large head or feet that are much too small for the body. The best way to check proportions is to hold up a pencil to the subject and slide your thumb up and down it to measure the various elements. This will quickly show you the size of a hand in relation to a forearm and the ratio of head-width to shoulder-width.

Another way to improve your drawing is to look not at the forms themselves, but at the spaces between them. If a model is standing with one arm resting on a hip, there will be a space of a particular shape between these forms. Draw this, not the arm itself, and then move on to any other "negative shapes" you can see. This method is surprisingly accurate and effective.

How is composition related to figure painting?

It is easy to become so bogged down in the intricacies of the human figure and face that composition is forgotten, but it is every bit as important as in any other branch of painting. Even if you are painting just a head-and-shoulder portrait, always give thought to the placing of the head within the square or rectangle of the paper, the background, and the balance of tones.

You will often find you need background or foreground interest to balance a subject. Placing your sitter in front of a window, for example, will give an interesting pattern of vertical and horizontal lines in the background as well as a subtle fall of light, while a chair not only supports the model, but its curved or straight lines also have pictorial potential.

Figures or groups of figures in an outdoor setting require equally careful pre-planning. You will need to think about whether to make them the focal point of the painting, where to place them in relation to the foreground and background, and what other elements you should include — or suppress. It is a good idea to make a series of small thumbnail sketches to work out the composition before you begin to paint.

Above: Mother and Child, *Greta Fenton. This tender group shows how effectively figures can be painted in watercolor. The artist has painted directly from life, working mainly wet-in-wet with a large Chinese brush and adding definition with delicate red crayon lines.*

What are the proportions of the figure?

The key to successful figure drawing is to get the various parts of the body in their correct proportions. This is easier said than done, because our eyes tend to mislead us into seeing some parts as larger or smaller than they really are.

Most artists gauge body proportions by taking the head as their unit of measurement. Allowing for slight differences from one person to another, the adult human figure measures seven to seven-and-a-half heads from top to bottom. Although no two people are exactly alike, it is helpful to keep the proportions of the "ideal" figure in mind as you draw.

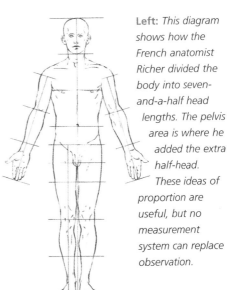

Left: *This diagram shows how the French anatomist Richer divided the body into seven-and-a-half head lengths. The pelvis area is where he added the extra half-head. These ideas of proportion are useful, but no measurement system can replace observation.*

What are the proportions of the head?

When drawing a portrait head, it is important to get the basic proportions correct, because it is these which help to produce a good likeness. Of course, it is partly the differences in proportion which distinguish one head from another, but it is useful to start by getting the basic, or "normal," head proportions established.

Drawing the human head becomes easier if you break it down into manageable portions: draw an outline of the head; sketch guidelines to enable you to position the features; and adjust the position of the features by observing the face before you.

Think of the head as an egg sitting on top of the cylinder of the neck. From the front, the egg is upright, while from the side it tilts at roughly 45 degrees. Next, position the features, and here the "rule of halves" is useful. Sketch a horizontal line halfway down the head: this marks the position of the eyes, and from here gauge the eyebrow line. Sketch a line midway between the eyebrow line and the base of the chin in order to find the position of the base of the nose; then draw a line midway between the base of the nose and the chin to find the line of the lower lip. Finally, draw a vertical line down the center of the head to guide you when positioning the features on either side.

Once your guidelines are drawn, use them to check the positions of the features of the head you are drawing.

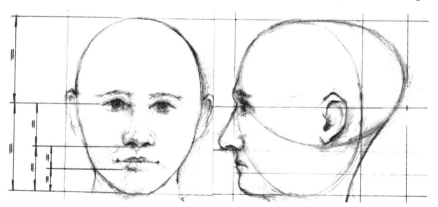

Above: *The shape of the head is enclosed frontally in a rectangle. The head in profile fits into a square with sides equal to the height of the frontal rectangle. As a general guide, the head comprises two equal ellipses — one positioned vertically and one horizontally. Use the rule of halves to find the correct positions of the features.*

How do I mix flesh tones?

There is no single formula for painting skin tones, because they vary enormously, even within the same racial group — and between parts of the body.

Commercially available flesh–tint colors are dull. With suitable experimentation, you can create hues that are infinitely changeable, enabling you to capture all the warmth and subtlety of human flesh. For example, a suitable mixture for white skin might comprise roughly equal quantities of white, alizarin crimson, and yellow ochre, with a touch of cadmium red. Mixing these colors in different proportions gives you a good base from which to start. Red, umbers, and siennas can be added to warm up the light-struck areas, while blues, violets, and greens can be added in the shadow areas and receding places.

The colors that you mix will depend on the skin type of your sitter. Decide first whether it is a warm ivory color, pale and sallow, ruddy, or olive. Mix a mid-tone and apply it, well diluted, as a base color. Paint quickly and freely, wet-in-wet. Working from this base color, place the lightest and darkest tones, and then work on the mid-tones — those transitional areas between light and shadow. Remember that the colors of the sitter's clothes and background will affect the flesh tones, so develop these along with the face.

Gamboge + a touch of madder lake

Yellow ochre + madder lake

Yellow ochre + madder lake + a touch of cobalt blue

Yellow ochre + madder lake, very diluted

Gamboge + burnt sienna + a touch of viridian

Viridian + gamboge +burnt sienna

Left: *There is no set formula for mixing skin tones: your best plan is to experiment with different combinations of color and see which ones work best.*

How do I achieve a likeness?

Capturing a likeness of your subject is not just a question of making an accurate reproduction of the physical features. It is also about getting under the skin of people and revealing something about their personalities and their inner feelings. When these two aspects — sound observational drawing and an emotional empathy with the subject — work in tandem, the result is a portrait that is alive and meaningful.

Capturing personality

Assessing personality will present few problems if your sitter is someone you know well. But even if your sitter is a total stranger, you will find that most people reveal something of their personalities as soon as they enter a room. The way in which a person dresses and speaks, and the gestures and mannerisms that he or she habitually adopts, all give important clues to personality.

Before you even put pencil to paper, try to absorb a general impression of your subject. Is the person confident and outgoing, or shy and sensitive? Does the face have the innocence and bloom of youth, or is it etched with the lines that come from decades of laughter and sadness? Look out for repeated gestures and mannerisms, the tilt of the head, the set of the jaw, the pose adopted when sitting or standing. All of these things are part of an individual's "personal imprint," and every bit as important as physical features in distinguishing him or her from other individuals.

As you work, talk to your sitter, and do not be put off if he or she moves slightly or if the expression alters. If you require the model to sit like a dummy, it will hardly be surprising if the finished portrait looks like one.

Sketch out the framework of the head and shoulders, looking for the dominant angles, masses, and shapes. Once these are right, you can get down to the finer details. When drawing the facial features, keep checking against the model to see that each is correctly positioned in relation to the other. Does the inner corner of the eye line up with the corner of the mouth? How wide is the mouth in relation to the width of the face? What is the distance between the base of the nose and the upper lip?

Above: *To familiarize yourself with a range of human facial expressions, make sketches from live models, or from photos in magazines and newspapers. Getting the features correct in relation to each other is important in capturing an individual likeness. Use your pencil or brush to check angles and distances between points on the face.*

ARTIST'S TIP

In a sense, a good portrait contains an element of caricature. In order to inject life into your portrayal, you need to get the essence of your subject, to seek out and emphasize those distinguishing features, gestures, and mannerisms that make that person unique.

How do I paint the moving figure?

Before starting to draw a moving figure, it is important to spend some time simply observing your model. Try to feel the overall rhythm of the figure's movement and to understand how it works. Mimic the motion yourself in order to experience the way in which the balance of the body changes at different stages during the action.

When you feel ready, make some quick sketches. Try to capture the main actions in just a few lines. Don't worry about detail, but be loose in your sketching, using fluid arm movements rather than working tightly. As you sketch, you will find that you develop your own shorthand of quick strokes and lines that "catch the movement."

While watching your subject, you will notice that certain phases or positions within the movement are more active than others. In a walking figure, for example, the point at which the leading foot is about to hit the ground and the other foot is about to lift is the peak moment of the action. If you can capture this peak moment in a stride, a kick, a swing, or a reach, your figures will always have energy and life.

When sketching the figure, use the restating method. A single mark outlining a leg will make it look static, but a series of lines will give the impression of change and movement. When painting, apply washes freely to create the "blurred" impression associated with movement.

The composition of a picture is another important factor in accentuating movement. For example, in capturing the exciting atmosphere of a group of athletes racing toward the finishing line, you might choose a head-on viewpoint that propels the viewer straight into the action.

Above: Circus Cyclist, *Jake Sutton. The artist draws with his brush to create a marvelous sense of excitement and urgency. The variation in brushstrokes, some like fine pencil scribbles and others swelling and tapering, seems to increase the momentum of the figure, propelling it forward, and adds to the impression of balancing.*

Is there a use for photographs in figure painting?

Photographs provide a useful source of reference for portraiture and figure work, particularly if the subject is in motion. It is advisable, even so, to work from life wherever possible, and because a watercolor study is not likely to take as long as an oil, it should not be difficult to persuade people to sit.

You can take a photo, before you even begin to draw, to record the light and other elements which may change during the painting process. Compose the picture carefully, and give thought to both the background and the lighting. The light will define the figure by casting shadows in a certain way, and lighting can also be used to create atmosphere. A figure seen against a window will appear almost in silhouette, while a strong side light will dramatize the subject with strong tonal contrasts.

Above: Blowing Bubbles, *Elaine Mills. This painting was made from a photograph. The artist wished to capture the child moving, not in an artificial-looking pose. The painting itself was built up in a series of thin washes, the colors kept light and clean throughout. The details of the face were done last.*

What is Rembrandt lighting?

Rembrandt lighting is a dramatic lighting effect, named after the great Dutch master who used it in his portraits.

The method involves positioning a small concentrated light source to one side of the sitter so that the light falls at a sharp angle. This creates a spotlight effect, in which the sitter is revealed in dramatic contrast against a dark, shadowy background. Because the angle of the light is so sharp, it casts deep, brooding shadows into the eye sockets and plunges the lower part of the face into near darkness.

If handled well, this type of lighting lends a mysterious, enigmatic mood to a portrait, but obviously it is only suitable for some subjects.

CHAPTER

8
STYLE

What is Impressionism?

The guideline for an Impressionistic approach is to free your mind from what you think you know about your subject and respond to the purely visual sensations of color and light. Monet described it as a "naïve impression" — not a simplistic image, but unique, consisting only of what you saw in that place at that moment. Watercolor is the ideal medium to capture this impression of light and color.

The Impressionists worked directly on to white canvas, letting new colors blend with undried layers below, working wet-in-wet (see *What is wet-in-wet painting?*). They exploited the immediacy of watercolor to reflect the transience of observed realities.

Left: The Island Garden, *1892, Childe Hassam. Inspired by Monet, Hassam painted this famous garden of his friend Celia Thaxter, on Appledore Island. He captured the flickering effects of the air, sun, and water.*

What is Expressionism?

Expressionist painting goes beyond appearances, using devices of technique and composition to develop mood and atmosphere. By exaggerating particular aspects of the subject, the artist directs the viewer's response toward the emotive qualities of the picture, which is drawn subjectively rather than objectively. An Expressionist painting need not be unreal or threatening, but it must challenge our perceptions of reality.

Composition and Stylization

Distortion and stylization are characteristic features of the Expressionist approach. In landscape, architectural, and interior subjects, selective composition and distortion of the subject can create a particular mood. The impression of space and distance can be heightened through exaggerated perspective. Paintings of the figure commonly use a method similar to caricature. The characteristic features of faces and bodies are exaggerated, even to the point of deformity, as a means of emphasizing the narrative point of the image or its associations. It can be helpful to simplify detail, so that a person or object is reduced to those essential ingredients that still make it recognizable. But Expressionism does not always aim to provoke or disturb. Sometimes Expressionist devices are used to create appealing visions of alternative realities.

Above: Woman Upside Down, *1915, Egon Schiele. Working in watercolor as an adjunct to line work, Schiele uses dominant high-key tones to create an unnatural brightness.*

How is mark-making a part of Expressionism?

A typical feature both of Vincent van Gogh's work (1853–1890) and of later Expressionist painting is the extremely vigorous brushwork. The masses of heavy directional strokes construct form and texture with exaggerated emphasis.

Drawing with the brush is used as a means of expressing mood and atmosphere (see *What is brush drawing?*). Outlining individual shapes draws attention to features that have been distorted or exaggerated. Areas of color composed of interactive brushmarks — dots, dashes, ticks, and scribbles — allow flat surfaces and simple planes to take on an expressive character. Coherent form can still emerge from this mass of strokes.

Above: Taureau Rouge, *Franz Marc. The artist experimented with the expressiveness of color and Cubist-inspired rhythmic harmonies in watercolors of animals.*

How can I explore the Expressionist style?

Expressing character

Using a photograph as reference, make a brush drawing in watercolor of an animal or a bird intended to express its character — the power and aggression of a beast of prey, for example, or the timidity of a deer or rabbit. Use a limited, non-naturalistic color range appropriate to the mood of your subject. Avoid the temptation to make a simple likeness. Pay attention to the variety of brushmarks you can use to describe the creature expressively.

A sense of place

Choose an interior or exterior view — one not containing too much distracting detail — and make several watercolor sketches investigating the "sense of place" through varying moods. Select specific features of the scene as the basis of each composition, then interpret the shapes and develop the color scheme in a manner appropriate to the chosen theme. Try using a large brush and loose brush strokes, and lay in the colors freely and rhythmically.

What is pure abstraction?

In abstract painting, which makes no direct reference to the real world, it is the basic ingredients of color, composition, and execution that become the subject of the work. Watercolor's ability to be worked loosely and dramatically lends itself to the abstract style.

Some artists, like Piet Mondrian (1872–1944), arrived at a form of pure abstraction by working their way through figurative styles and processes of abstracting from nature. In the late twentieth century, with many previous examples to learn from, others moved quickly into this way of working early in their careers.

It may be impossible to eliminate all references to the normal range of human visual experiences, and sometimes a viewer may feel that a landscape reference can be seen in a painting that purports to be wholly abstract. This is because we tend to see marks on canvas or paper as suggesting space and form; and when we are looking for references to real situations or objects, we may identify what seem to be reasonable associations. However, this is unconnected with the artist's intentions; when working in a purely abstract mode, the artist is dealing with shapes and forms, colors and textures in terms of what they actually are, not what they represent.

Left: Painting with White Form, *1913, Wassily Kandinsky (1866–1944). The looseness and ease with which Kandinsky used watercolor contributed to the abstract appearance of transitional works that still contained landscape elements.*

What are the basic elements of pictorial composition in abstract work?

As in any form of image-making, the abstract artist deals with basic elements of pictorial construction: line; mass; color; tonality; surface texture and pattern; shape; contour; spatial depth; and apparent volume. If the painted image is not to refer to anything known, the important question seems to be, where do you start? What should be the next mark, and why? It is because such questions cannot be answered precisely, or by reference to something else, that many people find it difficult to be interested in abstract art. The logic of an abstract painting may seem too personal and inaccessible.

The logic of abstract work may lie in what the painting is supposed to do, and in what it should not do. Mondrian is a good example to study because his geometric grids and limited color range appear restrictive and severe. His intention was to create "dynamic equilibrium," a sense of movement and tension in an image that also had absolute balance.

Mondrian chose the right angle as a pure and constant factor — it is a fixed and balanced relationship between two lines. When using this to construct squares and rectangles, however, he still had a great deal of scope to vary the proportions and interactions of these simple geometric shapes. In limiting his color range to the three primaries and the neutral colors of red, yellow, blue, black, white, and grey, he had a palette which incorporated absolute qualities of hue and tone. When applied to the geometric grid, they influenced the tensions and balances in the painting.

Challenging preconceptions

What these paintings are not supposed to do is to create an impression of three-dimensional space, or refer to external reality. In this sense, Mondrian challenges both himself and the viewer to discard received notions of pictorial space. We might tend to relate a grid structure to architectural frameworks. The use of black and white usually implies light and shadow, a means of modelling three-dimensional form. But Mondrian's paintings lie flat on the picture plane, and neither the color nor the construction suggest any element of real space and form. This requires careful judgement of the proportions of the shapes and the extent of the color areas, and their interactions. Painterly features are also eliminated — the color is flat and opaque, the marks made by the brush are virtually invisible.

Where do I draw inspiration from to create abstract art?

There are two methods of developing an abstract style. One is to use objects and images from the real world as reference points from which you evolve a personalized, "abstracted" interpretation. The other is to employ purely formal pictorial elements and material qualities — such as non-referential shapes and color relationships and surface effects — directly relating to the material properties of the chosen medium. In this case, the medium is watercolor.

Real world abstraction

Abstracting from nature we can take to mean deriving abstract imagery from things actually seen. Landscape is a frequently used resource for this kind of approach, perhaps because its enormous scale enables us to look at it in broad terms and disregard incidental detail that cannot be clearly identified at a distance. But this basic method can equally well be applied to other themes like figures, natural and manmade objects, indoor and outdoor environments, and events.

To describe this process of abstract analysis in the most simple terms, we can take possible examples and relate them to figurative interpretations. For instance, a landscape of fields, hedgerows, and distant hills can be seen as a series of rhythmic shapes, each of which has a dominant color; and abstract painting of such a view might look something like the image that a figurative painter would achieve while blocking in the landscape in the early stages of the painting — broad contours and color areas not yet broken up by the particular detail of individual features. In the same way, a face can be seen as an elliptical shape, colored an overall uniform pink. Arms and legs can be interpreted as basically cylindrical forms and clothing as separate areas of bold color and pattern.

Often, in any subject, you can identify linked and repeated shapes and forms that give a sense of unity to your interpretation. The same type of linkage can be made within the range of hues and tones that you see, so that you can discover a pattern of similarity and contrast. Abstraction means initially breaking down what you see before you into simple, sometimes very obvious, visual elements. You can then start to examine the detail, as you would in a representational painting, and see what other information you are provided with that enables you to reinterpret and elaborate your basic image.

How do I translate a visual image into an abstract image?

Collage from a landscape or still life

Choose a landscape theme — a view that is familiar to you — or set up a simple still life, and create an abstracted color study using cut and torn pieces of colored paper collaged to your base paper. Try to deal with distinctive, strong shapes, eliminating small-scale detail. Do not worry about making the shapes too precise, and allow the paper pieces to overlap and modify each other. You can make changes simply by gluing pieces over each other.

A painted abstraction

Repeat the project above, but using watercolor paint to create the colored areas. Apply the paint in different ways to vary the surface qualities within the different shapes. For instance, opaque body color mixed with a pigment, next to active, broken brushwork.

Drawing with color

Using a similar subject, make a color drawing with brush and paint (see *What is brush drawing?*), following the contours of shapes and including detail elements, such as interesting textures on the surface of the objects you are looking at. Try using a tinted piece of paper for your painting in this project, so that you have to select your paint colors boldly to make sure they have an impact.

Above: Doris Tysterman, *Roy Sparkes.*
Some natural forms have very strong, characteristic shapes that can be isolated and rearranged. Abstraction is frequently involved with the pure sensations of color and texture available from a particular medium or mixed-media approach. A natural subject such as flowers can suggest ways of unleashing these properties freely, but from a basis of observed reality.

What techniques could be used to make a gestural abstraction painting?

Using watercolor, start by making very free marks on your canvas or paper, initially using lines to create rhythm and direction, then adding broad areas of color and texture to develop the image.

As you progress, study the surface qualities and color interactions that emerge, and make deliberate decisions to enhance those that work successfully and to adjust those that do not.

Which abstract artists would be good to study?

Wassily Kandinsky (1866–1944)

An influential figure in the development of abstract art, Kandinsky is credited with having produced the first abstract painting, an untitled watercolor painted between 1910–13. He developed a free style of abstraction through a series of works under the titles *Composition, Improvisation,* and *Impression.*

Mark Rothko (1903–70)

In large works consisting of rectangles, borders, and stripes with heavily brushed, painterly textures, Rothko was a pioneer of the style of abstract work that came to be known as "color field painting."

Jackson Pollock (1912–56)

The leading figure of the New York School of Abstract Expressionism, Pollock developed the famous "drip painting" method of spattering and pouring the paint on to large canvases laid on the floor. Seemingly random, the effects and results are, in fact, expertly controlled and skillfully manipulated.

Frank Stella (b. 1936)

Stella was a leading figure of hard-edged abstraction in the 1960s, with austere stripe paintings in closely controlled colors. He later moved into a more active, Expressionist style of work, creating three-dimensional reliefs covered with brilliant patterns and textures.

9
FINISHING
AND DISPLAY

The painting is finished, what now?

When you have finished your watercolor and allowed it to dry thoroughly, it is time to remove it from the board and decide how to display it.

Your first task is to cut it carefully from the board. The edges of the stretched paper should be cut with a sharp Stanley knife or scalpel, but in doing this the released tension is so great that the paper may tear, ruining all your efforts. To avoid this, cut opposite ends of the paper rather than working around the rectangle or square with your knife. Once the watercolor has been removed, trim the edges with your knife, a straight edge and a triangle; this will make matting easier.

If you did not clean your drawing board last time you used it, you may find that any remaining pieces of gummed tape have stuck your paper to the board. The only solution is to take a sharp single-edged razor blade to carefully edge the paper off the board; two pairs of hands may be useful for completing this task.

ARTIST'S TIP

Unil you are ready to mat and frame, store your finished watercolors with tissue paper between each one, in a portfolio or large drawer. Be certain to keep them clean and dry.

How are watercolors best shown?

Watercolors are best displayed using window mats. The matting card is cut to a shape which will frame the painting and placed on top of it. Not only does this method overlap the edges of the painting to give a more finished effect, the mat also acts as a buffer, protecting the work from the glass.

Light-toned or neutral colors are usually more suitable for mats; black, white, and dark colors tend to dominate and detract from the subtlety and color of your painting. A strong work, however, may be able to stand up to a darker mat, so it

is a good idea to try your painting against various sheets of colored paper.

Sometimes a colored line is drawn around the inside edge of the mat, providing support, and emphasizing the horizontal and vertical planes. It can be drawn with a sharp colored pencil, or a ruling pen, or brush and ruler, and should echo some of the color characteristics of the watercolor, providing a visual link between the painting and the mat. Always use a triangle and ruler for precision.

How do I cut mats?

If you plan to mat your paintings yourself, it is well worth investing in the correct equipment; this will help ensure that you make a good job of finishing off your work. In the below demonstration, a ready-made clip frame is used.

YOU WILL NEED

Matting board, cut to size
Piece of thin card
Masking tape
Craft knife
Long steel ruler
Cutting board
Ready-made clip frame

Cutting a window mat

1 Measure the picture, deciding whether you want the mat to cover any of the edges.

2 Cut the board to fit the glass of the frame, and then mark the measurements for the window.

3 When all the edges and corners have been cut cleanly, lift the board by the edges and let the unwanted piece slip out.

4 Position the mat, then fix the picture to it with a piece of masking tape. Don't tape around the edges.

5 Place the picture and mat on the backing board. Put the glass on top, and clip all together.

6 Be warned however, clip frames don't give as much protection as actual frames, as dampness can creep in.

How do I frame my watercolor?

Although you can pay a framer to mat and frame your work, it is cheaper and more satisfying to frame it yourself. A variety of framing materials and ready-made frames are sold in artists' stores, and these help to make your task easier.

The store where you buy the framing will mitre the frame for you if you provide a list of measurements. Double check these several times until you are satisfied that they are accurate.

To protect your picture, choose from: picture glass which is simply lightweight glass; non-reflective glass which prevents glare; or Perspex which can scratch. Hardboard is ideal for backing.

How do I assemble a frame?

1 Before clamping, white wood glue is applied to the cut ends for the frame.

2 Assemble the four sides of the frame in the clamp, tighten as necessary.

3 Using a vise, drill shallow holes to prevent molding from splitting.

4 Insert the panel pins at an angle toward the outside of the molding.

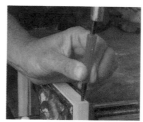

5 Use a nail set to knock the nails fully into the frame, to protect from hammer blows.

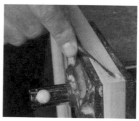

6 Repeat for other sides of frame. Fill the small holes with wood putty.

What is the best way to keep records of my paintings?

It is useful to keep a comprehensive photographic record of all your work, and slides or digital photos are probably the most convenient methods. The quality of your photographs is important, and it is best to mount your camera on a tripod so that it is steady throughout the exposure; a pair of anglepoise lamps should provide sufficient light.

If you are sending slides or images on disk to a gallery, make sure they are clearly marked with your name, the title of the picture, and date painted, as well as its dimensions and the medium used.

How do I prepare a digital image for exhibition?

Digital images have become widely accepted for submitting paintings to exhibitions. Usually exhibition directors require the submission of a j-peg image made at 5 in. (12.5 cm) width by proportional height at 300 dpi.

This preparation is easily accomplished using the Adobe Photoshop application or similar. If you do not have a program like Adobe Photoshop, enquire at a photography shop for assistance in preparing digital images.

How do I exhibit my efforts?

Art societies, libraries, and galleries are always open to the submission of work. Lists of future exhibitions are published frequently, showing submission fees, venues, and size restrictions.

There are several ways in which you can present work to potential exhibitors. Transparencies are convenient. Or, use a portfolio to protect your pictures. Pages from your sketchbook can also be included in a portfolio, and work that has been matted.

If you are lucky enough to have your pictures hung in an exhibition, a tremendous variety of lighting is available, one of the most popular systems being ceiling spotlights. The background against which your work is hung and the method by which it is suspended may be beyond your control. Try to ensure that your pictures are hung on a white or neutral-colored wall in such a way that the method of support is as inconspicuous as possible.

Glossary

Aquarelle

A painting executed in transparent washes of watercolor or a drawing colored with thin washes of paint.

Blocking in

The technique of roughly laying out the forms and overall composition of a painting or drawing in terms of mass and tone or color.

Body color

Paint, such as gouache, which has opacity and therefore covering power. In watercolor, this can be achieved by adding white to eliminate transparency. Body color may be used to add highlights and the glints in eyes.

Chiaroscuro

This term literally means "light–dark" and originally was used in reference to oil paintings with dramatic tonal contrasts. It is now more generally applied to work in which there is a skillfully managed interplay of highlight and shadow.

Composition

The arrangement of various elements in a painting or drawing — for example, mass, color, tone, contour.

Dry brush

A means of applying watercolor with a soft, feathery effect by working lightly over the surface with a brush merely dampened with color. The hairs may be spread between finger and thumb.

Figurative

This term is used in referring to paintings and drawings in which there is a representational approach to a particular subject, as distinct from abstract art.

Foreshortening

The effect of perspective in a single object or figure, in which a form appears considerably altered from its normal proportions as it recedes from the artist's viewpoint.

Fugitive color

Certain pigments are inherently impermanent, or the color may fade due to the action of natural elements, especially sunlight. A paint or dye which is short-lived in its original intensity is known as fugitive.

Gouache

A water-based paint made opaque by mixing white with the pigments. Gouache can be used, like watercolor, to lay thin washes of paint, but because of its opacity it is possible to work light colors over dark and apply the paint thickly.

Grain

The texture of a support for painting or drawing. Paper may have a fine or coarse grain. Some heavy watercolor papers have a pronounced grain which can be exploited to achieve effects of highlights and broken color in painting.

Ground

The surface preparation of a support on which a painting or drawing is executed. A tinted ground may be laid on to white paper to tone down its brilliance.

Gum arabic

A water soluble gum made from the sap of acacia trees. It is used as the binder for watercolor, gouache, and soft pastels.

Hue

This tern is used for a pure color found on a scale ranging through the spectrum — that is red, orange, yellow, green, blue, indigo, and violet.

Local color

The inherent color of an object or surface that is its intrinsic hue unmodified by light, atmospheric conditions, or colors surrounding it.

Masking

A technique of retaining the color of the ground in parts of a painting by protecting it with tape or masking fluid while colors are applied over and around the masked areas. This practice gives the artist freedom to work over the whole surface without losing shapes or areas of highlight.

Monochrome

A term describing a painting or drawing executed in black, white, and grey only or with one color paired with white or black.

Not

A finish in high quality watercolor papers which falls between the smooth surface of hot-pressed and the heavy texture of rough paper.

Opacity

The quality of paint which covers or obscures a support or previous layers of applied color.

Perspective

Systems of representation in drawing and painting which create an impression of depth, solidity, and spatial recession on a flat surface. Linear perspective is based on a principle that receding parallel lines appear to converge at a point on the horizon line. Aerial perspective represents the grading of tones and colors to suggest distance, which may be observed as natural modifications caused by atmospheric effects, such as mist.

Picture plane

The vertical surface area of a painting on which the artist plots the composition and arranges pictorial elements to suggest an illusion of three-dimensional reality and a recession in space.

Pigment

A substance which provides color and may be mixed with a binder to produce paint or a drawing material. Pigments are generally described as organic (earth colors) or inorganic (mineral and chemical pigments).

Spattering

A method creating a mottled texture by drawing the thumb across the bristles of a stiff brush loaded with wet paint so the color is flicked on to the surface.

Stippling

The technique of applying color as a mass of small dots, made with the point of a drawing instrument or fine brush.

Support

The surface on which a painting or drawing is executed — for example, canvas, board, or paper.

Tone

In painting and drawing, tone is the measure of light and dark as on a scale of gradations between black and white. Every color has an inherent tone — for example, yellow is light while Prussian blue is dark — but a colored object or surface is also modified by the light falling upon it, and an assessment of the variation in tonal values is important to indicate the three-dimensional form of an object.

Tooth

A degree of texture or coarseness in a surface which allows a painting or drawing material to adhere to the support.

Underpainting

A technique of painting in which the basic forms and tonal values of the composition are laid in roughly before details and local color are defined and elaborated.

Value

The character of a color as assessed on a tonal scale from dark to light.

Wash

An application of paint or ink considerably diluted with water to make the color spread quickly and thinly. A wash can be gradually further diluted to create a gradation in tone.

Wet-in-wet

The application of fresh paint to a surface which is still wet, which allows a subtle blending and fusion of colors.

Index